HERMÈS
STRAIGHT FROM THE HORSE'S MOUTH

HERMÈS
STRAIGHT FROM
THE HORSE'S MOUTH

LUC CHARBIN

Illustrated by
Alice Charbin

Foreword by Menehould du Chatelle
Translated from French by Hazel Duncan

ABRAMS, NEW YORK

Foreword

Around forty short stories chosen from the treasure trove of Hermès' oral archives make up this collection*. The spoken word is given pride of place and animated throughout by the inventive vivacity of the collection's original illustrations. Here, past and present voices take on life and colour in order to narrate these verses of a modern-day odyssey.

These are the voices of master artisans, often wise and always rich with observation and experience. They are persuasive when faced with a stubborn apple tree; passionate about highly accomplished craftsmanship; precise when describing the bead of sweat running down a man's spine at the outset of delicate work, or the weakness in a woman's knees after a day spent squeezing a heavy sewing clamp. Their vivaciousness is marked by Parisian cockiness, down-to-earth lilts from Mazamet and Margaux, and a variety of foreign accents – true Spanish and fake English. Some are resounding, having boomed through trade union megaphones; others are full of laughter, cheeky or shy, amazed, irritated, reserved, verbose with clever remarks, quick with repartee, or of few words. These are the voices of Hermès, ringing with authenticity. In unison, their diversity blends into the humming sound of a company, a hive of activity for almost two hundred years; a company committed not only to the skills honed through work, but also to the word of mouth that passes them down together with a long line of events and experiences, the spoken word woven into the fabric of life, infused with memories of childhood and homelands, destinies and dreams.

Hermès thus perpetuates, among its most cherished skills, the marvelous craftwork that is storytelling, and perhaps

rarer still, the art of listening. Saddlers, leather craftspeople, silk manufacturers and goldsmiths, sales assistants, window dressers, designers, gardeners, electricians and storekeepers: each is a storyteller, some are poets. Aware they must transmit their expertise, they do not leave 'the house' without bequeathing something: their tools perhaps, or some trick of the trade. More generously still, they recount their own anecdotes, which irrigate the luminous, warm and humane memory of Hermès.

Invited to delve into the unpublished archives of Hermès, part of its rich heritage, Luc Charbin was guided by Herodotus. In the footsteps of this traveller and storyteller, the father of history and geography, he had to play detective at times to disentangle the threads of truth from legend, allowing legend to trump truth on occasion, provided it was golden! He brought back this story told in several voices and devised as a collection of fables and vignettes, each headed with a savoury title. Some, though very short, open up new worlds through the purity and transparency of their prose. With the delicacy of a sparrow pecking at the fresh dung in Annie Beaumel's window display, Alice Charbin's pencil depicts that perfect detail, her virtuosity and humour forever nurtured by the 'milk of human kindness'.

You will follow some extraordinary and farcical adventures – the pursuit of a white rhinoceros that disappears in Switzerland, reappears in Colorado and returns to Faubourg Saint-Honoré; not forgetting glimpses of the Wild West (in France), the Normandy coasts, the Thar Desert, a Zen monastery in Japan, the workshops in Pantin, or that moment on a flight over the Channel marking the beginnings of an iconic bag – and you will hear, dear reader, the heartbeat of Hermès.

Menehould du Chatelle
Director of Hermès' Cultural Heritage

* In the 1960s, Hermès began to record the testimonies of its staff with a view to compiling an ever-expanding heritage of oral archives.

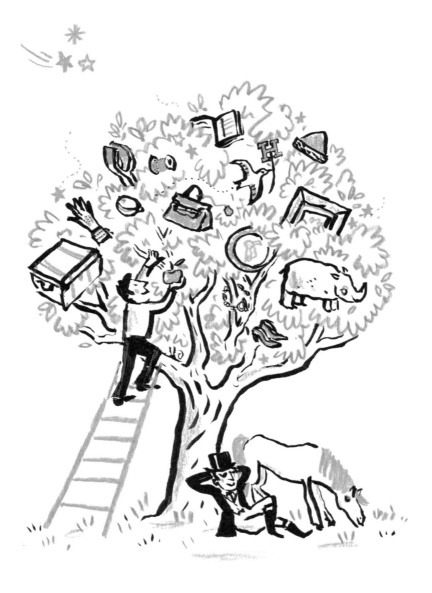

Table of Contents

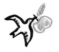

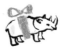

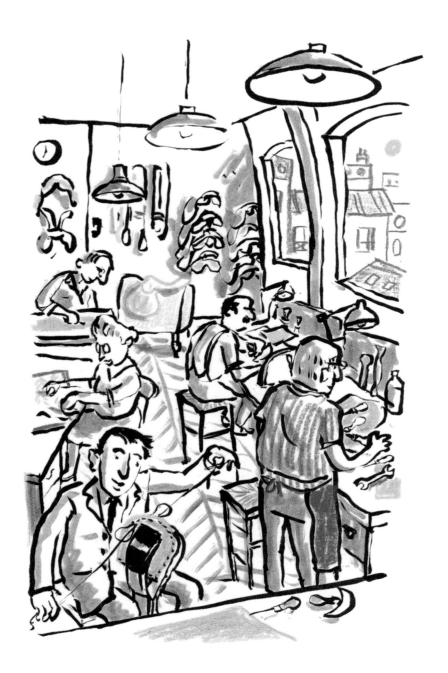

Lone Riders

The saddle is the beating heart of Hermès. It performs the feat of serving the horse, which must be protected, and its rider, who must be comfortable. Formerly on the *rue* Basse-du-Rempart in Paris, 'Hermès-sellier', a saddlery at the time, moved to 24 *rue* du Faubourg Saint-Honoré in the 1880s. The last floor has always been home to its workshop, the one nearest the sky, the one with the most light, just as Émile Hermès* had intended. 'You are now entering our sanctuary,' Robert Dumas, Émile's son-in-law, would whisper to visitors. His son, Jean-Louis, had his office situated in an adjacent room, as close as possible to this source of inspiration.

An atmosphere of peaceful industry reigns in this inner temple. Here, emulation is palpable and infinitesimal detail matters: the speed of execution; a trick of the trade; an individual technique. In the past, the artisans did not work with models, each relied on their own notebook. One craftsman recalled: 'Your notebook was like your toothbrush: not for sharing.' A sewing clamp holds the leather, an awl pierces the holes and two needles interweave the thread: the saddle stitch in the making. Its strength and beauty are remarkable. When others began to use sewing machines, Hermès' *mousquetaires* rose to the challenge, refining their stitch so that connoisseurs could distinguish between their inimitable craftwork and mechanical sewing. A saddle's underside rivals its upside; its inside outclasses its outside. Therein lies its nobility.

As a celebration of manual dexterity, this saddler's code of practice has influenced each of Hermès's crafts; and though such a daring gamble caused some amusement when Her Majesty the Machine ruled supreme, it is now the object of admiration – jealousy even.

* For more on the history of Hermès, see the glossary.

The Émile Hermès Collection

"There are two types of men,' said Albert Londres, the French journalist and author, 'furniture men, and suitcase men.' Émile Hermès, who had always been interested in objects designed for movement, particularly those for travelling, was a suitcase man.

At the tender age of twelve, Émile began a collection, the pieces of which would eventually be displayed in a museum on the third floor of the store. Still, yet changing, the museum sits above the bustle of the shop floor beneath, where items are sold and move on. Émile's treasures exasperated his wife. For her, collection meant clutter. She had a point. They were therefore housed in his office where they grew in numbers: embroidered saddles, items for travel, rare books, miniatures of all kinds and numerous other remarkable and ingenious curiosities that were often comical and unique. Here, objects are still preciously preserved, while downstairs, they leave with customers to tour the world. The rooms are filled with travel accessories, daggers engraved for fearsome hunters and fearless warriors, and pony-drawn carriages for children. Though constrained by restful inactivity today, each carries the memory of its movement; the magic of childhood is everywhere.

The museum is carefully preserved in its original state, displaying what, at a cursory glance, could be mistaken for an assortment of oddities from the past. But unwittingly, your eye is caught by the beauty of ornate mother-of-pearl, horn or ivory carvings,

the *guilloche* engravings on a metallic beaker, or the mastery of elegant marquetry; or perhaps your gaze lingers on an elaborate shaving case for the distinguished globetrotter. Approaching to take a closer look, you are drawn in, then swept away; your journey has begun. The Orient, Spain, England, France's *Ancien Régime* and *belle époque* joyfully lead the dance, captivating you with portable writing desks, miniature backgammon sets, walking stick-cum-parasols, a painting by Alfred de Dreux, or an unobtainable edition of lithographs. Evidently, generations of craftsmen not only enjoyed testing their skills but took great pains to do so. Fascinated, like a pointer on the hunt, you are seized by a curiosity which stretches back in time. On Tuesdays, Émile Hermès had the craftsmen visit the museum to heighten their sense of excellence. Each then returned to their workbench with a touch more food for thought, and a touch more inspiration.

Today, visits are by invitation; a pleasure and privilege to be savoured, slowly.

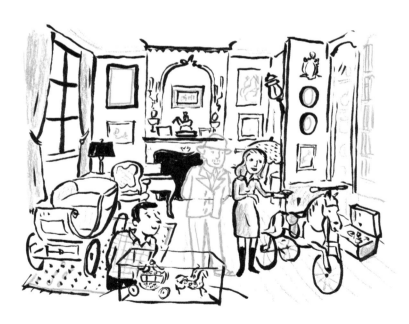

A Friendship that Grew

*T*he rooftop of 24, Faubourg Saint-Honoré is home to a garden in which a great variety of plants and flowers are tended with loving care. In its centre stands an apple tree, which for many years gave sufficient fruit for one of Émile Hermès's daughters, Aunt Aline, to make apple jelly. Yet, despite the repeated efforts of its guardian, Yasmina Demnati, the head gardener, the tree eventually became so poorly that she considered having it removed.

Standing firmly in front of it, Yasmina said in a threatening tone, 'Look here, if you don't produce apples, I'll chop you down.'

Autumn came and the apple tree produced not three, not two, but one single apple, which to Yasmina was obvious proof of its sense of humour; thus saved, its fruits were abundant for years to come. 'I am genuinely convinced that plants hear us, understand us and have feelings for us. I'm sure that the apple tree didn't like me to begin with, but when I threatened to kill it, it stopped putting me to the test and saved its skin. Now we get on just fine.'

'I introduce myself as the gardener, but officially I'm a skilled-gardener-landscaper, which is a bit of a mouthful, but that's the job title.' Brought up as an only child and bored in the company of children her age, Yasmina took to reading Voltaire's *Philosophical Dictionary*, which she readily admits not having understood. 'It's wonderful being an only child – solitude is a source of adventure.' Thanks to the parish priest, who took her under his wing, calling her 'Jasmine Flower', she became enthralled with the teachings and religious ceremonies of the Catholic Church, before turning to complex works on religion and esotericism as a teenager, and to Kabbalah and Hermeticism later on. Having studied at the École Du Breuil, a French horticultural school, she sat the requisite examinations to qualify as a skilled-worker-landscaper but, 'rubbish at maths', she failed them twice.

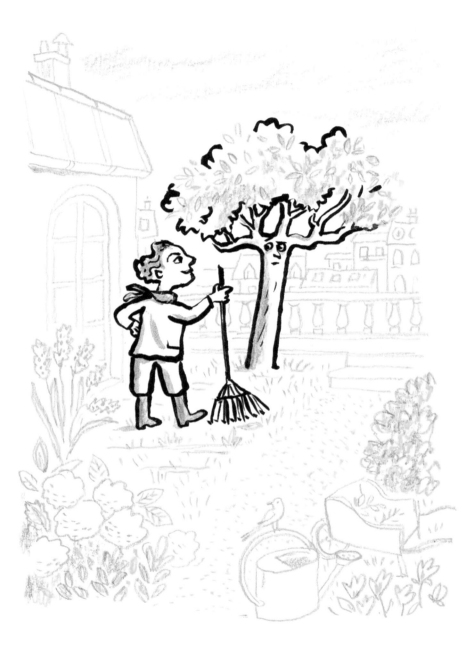

She cried with rage at the time, but now thinks of this setback
as a huge stroke of luck. Who can tell when, faced with opposing
headwinds, changing course will lead to a better destination?
 Yasmina began working for a landscaping company,
where she completed her training under the watchful eyes
of highly demanding head gardeners who shared their vast
knowledge generously. She met Jean-Louis Dumas in the 1980s,
who entrusted her with the upkeep of the rooftop garden where
a magnolia and the aforementioned apple tree grew surrounded
by a sea of white flowers. After a few years, she felt she could
rise to a greater challenge and decided to try her luck once more
at the examination. Having solemnly promised her plants
that she would return, she left her job, re-sat the examination
and passed with flying colours. True to her word, she returned
two years later to care for the gardens at the Hermès workshop
in Pantin, on the outskirts of Paris. This was an extraordinary
terrain into which, forever teeming with ideas, Jean-Louis Dumas
suggested introducing pink flamingos. The idea was rejected,
as pink flamingos have the unfortunate habit of flying away.
No matter, a dozen different varieties of pumpkin made up for
the flamingos with their colourful splashes of beautiful orange.
 'In fourteen years working for Hermès, there's never been
a dull moment,' Yasmina confided in 2006. 'What's more,
when I'm on holiday, I can't wait to get back. I now only take
days off here and there over the winter. You see, my job is to take
care of living things.' Of all the plants Yasmina has cared for,
perhaps the apple tree on the Faubourg's rooftop knows it best.

A Perfect Name

At the start of the 1960s, Catherine Chaillet, the young and highly avant-garde designer, opened Victoire, a boutique in the Halles district of Paris. With its lively atmosphere and artful decoration, fashionable young people flocked there, hungry for the latest trends. Among its regular customers was Jean-Louis Dumas, the future director of Hermès, who asked the talented Catherine to devise a new type of handbag for the famous brand. Pregnant at the time, she set to work, drawing a rounded curve, an elegant flap, an artfully designed strap, a lining to be made from lambskin and a large golden-metal clasp in the shape of an H, a memorable milestone for Hermès. No sooner had she finished the design, she gave birth to her baby daughter, Constance. Constance, why not? A perfect name for a bag*!

* Thereafter, several of Catherine's designs for Hermès were named after her children.

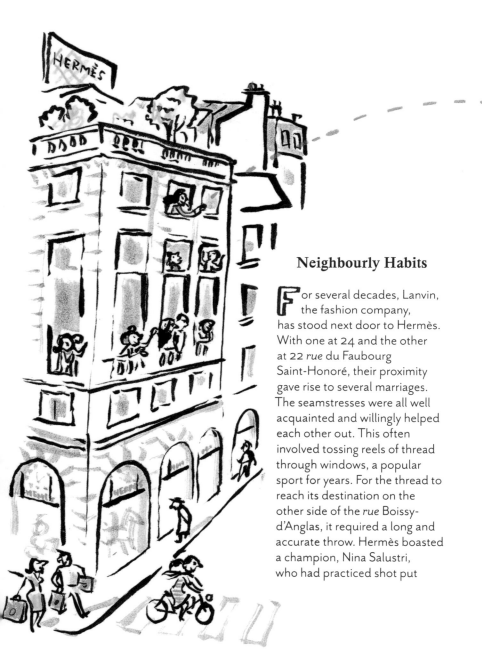

Neighbourly Habits

For several decades, Lanvin, the fashion company, has stood next door to Hermès. With one at 24 and the other at 22 *rue* du Faubourg Saint-Honoré, their proximity gave rise to several marriages. The seamstresses were all well acquainted and willingly helped each other out. This often involved tossing reels of thread through windows, a popular sport for years. For the thread to reach its destination on the other side of the *rue* Boissy-d'Anglas, it required a long and accurate throw. Hermès boasted a champion, Nina Salustri, who had practiced shot put

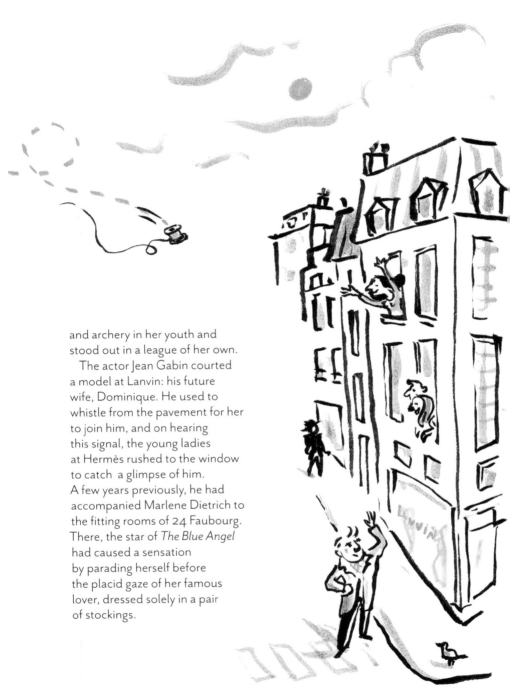

and archery in her youth and stood out in a league of her own.

The actor Jean Gabin courted a model at Lanvin: his future wife, Dominique. He used to whistle from the pavement for her to join him, and on hearing this signal, the young ladies at Hermès rushed to the window to catch a glimpse of him. A few years previously, he had accompanied Marlene Dietrich to the fitting rooms of 24 Faubourg. There, the star of *The Blue Angel* had caused a sensation by parading herself before the placid gaze of her famous lover, dressed solely in a pair of stockings.

Four of a Kind

In the 1930s, Hermès began to sell *carrés*, printed square-shaped scarves made of silk, offering their customers models bought in Lyon, the French capital of this precious fabric. Sales were promising – around one hundred per year – prompting Hermès to design its own motifs: *'Le jeu des omnibus et des dames blanches,'* the first Hermès scarf, made its appearance in 1937. In occupied France, silk became a rare and costly commodity, making the manufacturers in Lyon unable to meet demand. Émile Hermès, much concerned about the unreliability of their source of supply, decided the shop must take over the manufacture itself.

Out of the blue, he approached Camille Averous. Hired at a young age, Mr Averous had shown such competence that he was quickly noticed by the management. A former protestant scout – a guarantee of rectitude in the eyes of the director –, he came from Mazamet, a town in the Tarn region of France where the Tournier spinning mills were reputed for weaving yarn.

'Averous, you're from Mazamet, do you know the Tournier mills?'

'I lived opposite them.'

'You must be quite familiar with the weaving trade, is that correct?'

'Yes, I heard the clicking of looms all day and late into the evening until I was sixteen.'

'Good, come up to my office. I've a plan. Would you be interested in working with people who make silk?'

Averous listened attentively, increasingly aware of the scale of the task being assigned to him: 'This has to change. As you're from Mazamet, I want you to get to grips with everything involved in weaving. Though manufactured, the scarves have to be flawless.

For now, your hands are tied as silk is impossible to buy. But start planning, it won't last. The war will end and I will ask you to take charge of the printing. The designs will not be your concern, but making the fabric and finishing the hems, all of that will be your responsibility.'

Camille Averous set to work, studying supply chains for silk, imported at the time from Japan and China, before he approached Perrin, a firm in southeast France. Its looms would weave the scarves' fabric: billowing Japanese twill, a floaty silk material with a weighty feel. Then came the tricky part: engraving, a complex process which even companies such as the famed Bianchini-Férier often refused to undertake. As the management at Hermès racked its brains trying to find a competent supplier, providence came to the rescue. Marcel Gandit, a former engraving foreman in the French town of Bourgoin-Jallieu and a virtuoso in the trade, had just set up his own business. Overcoming his sense of awe, he knocked on the director's door to offer his company's services as the shop's exclusive engraver. The rapport between Robert Dumas, Émile Hermès's son-in-law, and Mr Gandit was instantaneous, both sharing the same passion for elaborate compositions and highly accomplished work. The engraving issues having been solved, printing was the only hurdle left. Two associates from Lyon took the risk of expanding their workshops to meet the expected demand.

Robert Dumas, appointed as artistic director of the scarves, was to hire designers, assisted by Annie Beaumel, who would have the last say in the colour tones. Averous and Gandit would oversee production. With this finely-tuned quartet taking the helm, the *carré* Hermès at last entered into the golden age to which it was destined. In 1972, the year he retired, Mr Averous could pride himself on having enabled Hermès to produce 380,000 scarves per year. Pragmatism, rigour and creativity: a winning hand which transformed the dream of Émile Hermès into reality.

Caught by the Clock

Roger Cornette had worked at Hermès for over forty years by the time he left in 1983. A qualified electrician, he began at a young age as a subcontractor before taking charge of general maintenance at 24 Faubourg and the other Hermès stores. Sometimes, he also did extra work for the Hermès, Dumas and Guerrand families, with whom he was on friendly terms.

When Roger was conscripted for National Service in Germany, Émile Hermès handed him an envelope with enough funds for a little entertainment, saying: 'When you're twenty, money comes in handy for having a little fun.' Another time, when Roger hesitated shaking Émile's hand since his own was covered in dust, Émile replied: 'It's an honour to shake hands with a man dirtied by his work.' Since that day, Roger claimed that Émile could have asked for anything: 'I'd have done it before he'd finished speaking.'

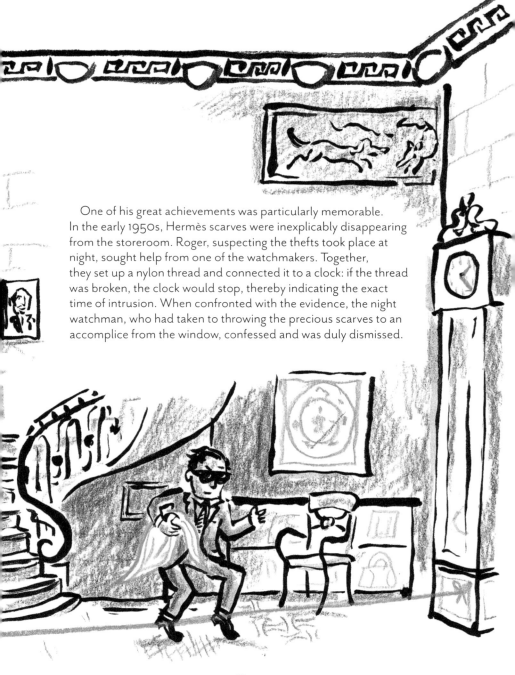

One of his great achievements was particularly memorable. In the early 1950s, Hermès scarves were inexplicably disappearing from the storeroom. Roger, suspecting the thefts took place at night, sought help from one of the watchmakers. Together, they set up a nylon thread and connected it to a clock: if the thread was broken, the clock would stop, thereby indicating the exact time of intrusion. When confronted with the evidence, the night watchman, who had taken to throwing the precious scarves to an accomplice from the window, confessed and was duly dismissed.

A Childhood Vocation

Born in Spain in 1935, Juan Iñiguez was the son of a drayman and the grandson of a blacksmith. In the wake of the Spanish Civil War, as families suffered from hunger, they sent their children into apprenticeships at a very young age. Juan was taken on by a saddler nine miles from his home. He weighed forty pounds, horse collars weighed twenty, and saddles ten. On his arrival, the boss asked him to go to Ramona's stable and put on her collar. Struggling to pick it up, Juan opened the stable door and found himself confronted with a mountain. Overwhelmed by the crushing weight of the collar and the enormity of the task, his legs began to buckle, and tears poured down his pale cheeks. He looked up at the mare, and she down at him. Gently, she lowered her head to help him slip on the collar, then, raising it once more, let it slide down her neck like an engagement ring, to settle above her withers. 'This is the job for me,' whispered Juan in awe.

After three years as an apprentice, Juan trained with a Spanish *primer maestro* who had fled Franco's forces. From him, Juan learned valuable lessons about both saddlery and life. 'When you can answer my questions, it will be time to ask some more,' he was told. A few years passed, and Juan, who had spent summers as a seasonal worker in France, decided to leave for Paris. He worked for a reputed leather merchant before being hired by Schilz, the saddler on *rue* Caumartin. The supervisor there, Mr Cotelle, was quick to spot his talent: 'You're a diamond straight from the mine, son. We'll soon have you dazzling so bright that people will be green with envy.' On Mr Cotelle's retirement, Juan left this saddlery of high repute but low ambition to put his expert skills, individual touch and headstrong personality at the service of Hermès. Saddle-making held no secrets for him, he knew every trick of the trade, the whys and wherefores, and the background to each one. Unmoved by modern ideas, the alleged virtues of synthetic fibres and passing fads, he was, together with his fellow craftsmen, the custodian of a heritage that clearly distinguished between novelties and discoveries. 'When something new came along, I would think it through for a couple of hours, head in my hands; that did the trick.'

In the 1980s, scores of leather merchants and their managers turned up one day to extol the marvels of a synthetic thread that never frayed. This invention would spare saddle-makers the task of coating their thread with beeswax. Arms crossed, Juan Iñiguez listened with a scowl on his face: 'When people you know in the leather trade tell you such rubbish, you really want to hit the roof!' He knew that linen thread had been coated with beeswax as far back as the Pharos, just as he knew the purpose it served. So he asked: 'Do you know why we use beeswax to coat our thread?'

'Not really.'

'Is that it? No one has anything else to say on the matter?'

Words from Michel Audiard, the French screenwriter, first sprang to his mind: 'I don't talk to blockheads; it educates them,' but Juan relented, explaining what they should have known by heart. 'First, a wax coating protects the thread from destructive

bacteria. It makes it supple in the summer and stops it from
breaking in the winter. The thread isn't better, it's just protected.
This method's tried and tested, why change it? Second, wax
is waterproof, protecting the stitching from rain. Your synthetic
thread doesn't cut the mustard. All you need is a change
in the weather for it to snap.'

A few days later, Juan bumped into Jean-Louis Dumas
at the annual horse fair. After taking him aside, Juan angrily argued
his case; but Mr Dumas was a good listener who knew about
the qualities of beeswax and how it protected linen thread.
The director was unequivocal.

'We're sticking with beeswax. Linen thread's more reliable.'

The matter was laid to rest. With a touch of pride, like a sailor
who has steered his ship clear of an iceberg, Juan still felt a sense
of relief years later.

'I'm not interested in new techniques. I left when I was sixty-two
and was still the fastest craftsman in the workshop. When we had
to stitch by hand, I used to say, "Make my day, show me your
method's faster than mine." They never were.'

Juan Iñiguez, who spent his life mastering the most delicate
handiwork in order to make the world's most beautiful saddles,
concluded on an ambiguous note. Was it mischief or wisdom,
tongue in cheek or sincere? 'I take my hat off to all those people
who have never done a thing in their life. Being active is easy,
I prefer people who haven't done anything at all.'

Gleaning Along the Shores

R obert Dumas liked to paint the sea, or rather the cliffs on the Normandy coasts where he had enthusiastically fished for crabs as a child. A collector at heart, he combed the beaches picking out pebbles, which he polished in a special tumbling machine. His clever hands would fashion some into simple necklaces for his daughters-in-law, threading a pebble with a leather thong fastened by a clasp he invented himself, much like a miniature buckle on a belt.

The story goes that before the war, while walking along the quayside of a harbour, he stopped short in front of an anchor chain, struck by the sheer beauty of its simple form. Taking a notebook from his pocket, he made a sketch of it. Then, on his return to work, he handed the drawing to Mr Pouthier, the head silversmith, to use as the design for a silver bracelet. The prototype for Chaîne d'Ancre was presented to Émile Hermès, who took to it wholeheartedly. From a solitary seaside stroll, a Hermès classic was born.

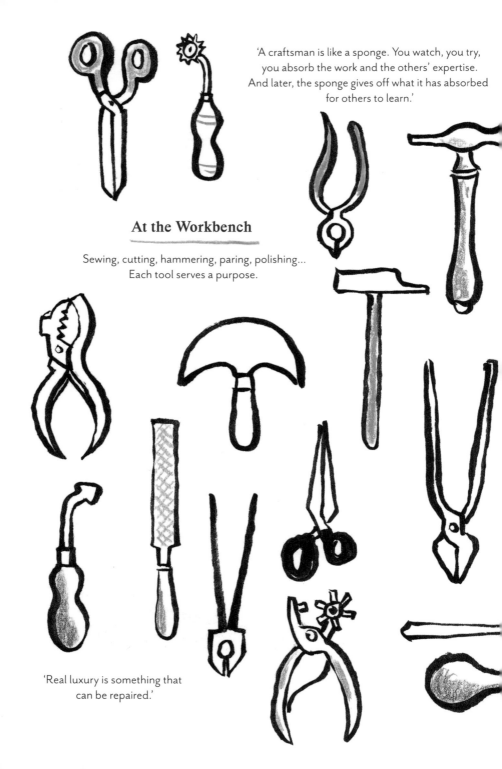

'A craftsman is like a sponge. You watch, you try, you absorb the work and the others' expertise. And later, the sponge gives off what it has absorbed for others to learn.'

At the Workbench

Sewing, cutting, hammering, paring, polishing...
Each tool serves a purpose.

'Real luxury is something that can be repaired.'

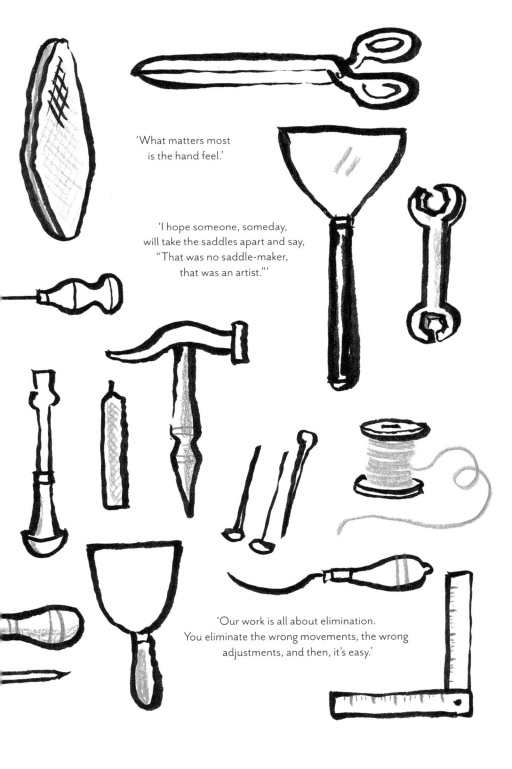

'What matters most
is the hand feel.'

'I hope someone, someday,
will take the saddles apart and say,
"That was no saddle-maker,
that was an artist."'

'Our work is all about elimination.
You eliminate the wrong movements, the wrong
adjustments, and then, it's easy.'

The Right Price

'You're the genuine five-leaf clover!' She could not have hoped for a warmer welcome to Hermès. When the director of the Deauville shop retired, Hermès looked for a replacement. As the sixth generation of her family to live in the seaside town, Corine Colas, née Castelain, was well acquainted with its well-heeled clientele. Her background in sales was not the only string to her bow: her ideas were astute, her character strong, and she had ambition. Received with open arms into Hermès in the 1970s, this woman who as a little girl dreamed of running a shop, revealed some of her secrets after a successful career spanning forty years: 'I'm told that I'm lucky, but I've put luck firmly on my side. I'm highly demanding, but particularly with myself. There is always something to be done in a shop, whether it's reviewing your customer files, overseeing repairs, putting the shine back into something dull or sharpening your pencil so you are always prepared!' Corine believes her vitality stems from a childhood of illness. 'Nowadays, I'm making up for lost time. I hardly sleep, I'm so keen to know and understand everything.'

Having insisted that the store in Deauville should open throughout the year, not just over the summer, she savoured each moment with her customers: 'People phone to make an appointment, then they try on clothes for hours on end. A whole morning can rush by with only one customer changing into the entire range of a collection's outfits. Afterwards, I explain the best combinations, matching garments with accessories, and so on. It's a question of applying a little psychology. If you ask the right questions, understand how to watch and listen, then you can't go

wrong. Customers must feel confident that you have their best interests at heart, which also means telling them when an item doesn't suit them. Selling anything to anyone is a recipe for disaster.' Owing to her patience and the trust she built up over the years, regular clients often ask for her assistance. She believes it her duty never to dress up her customers, but to pay close attention to their individual style with a view to long-term satisfaction. 'You learn a great deal from interacting with people. That's what I enjoy most.'

For her, a salesperson must provide guidance depending on the customer's personality. 'There are no problems, only solutions. The more uncompromising the client, the gentler I am. By never saying no, I make them relax and concentrate on what they are really drawn to. But to do that, you must know your products inside out. You must be able to explain their price and tell their stories; because each has its own, and Hermès takes pride in communicating them. The customers are enthralled.' The real challenge is to sell an article to someone who had not intended to buy one. She loves arousing people's interest in an object. In Deauville, she never promotes some items over others. The shop offer covers sixteen different categories of craft, and in her opinion, each rivals the other in terms of excellence and they all deserve equal attention. 'I don't try to sell what I like, that would be too easy; I try to sell what best suits the customer. It's all about convincing someone who's come to buy a black box calf Kelly that a denim-coloured leather Bolide bag actually suits them better. Now, that's selling for you!'

In 1989, Hermès acquired Saint-Louis, a handcrafted crystal maker. Jean-Louis Dumas, while looking through the company archives, stumbled upon documents concerning a magnificent mouth-blown flask. Seizing the opportunity of the approaching coronation of Akihito, the Emperor of Japan, he took the plunge. Hermès would produce an extremely limited edition of 'Empereur', as its making was a highly complex task. The head of the perfume division, Marie-Jeanne Chevallereau, then contacted a few handpicked stores, including the one in Deauville.

'Do you think you can sell this flask?

It costs twenty-five thousand francs.'
'What do you take me for! I want at least one.'
'Look, are you really sure?'
'No, you're right. Make it two!'
The day after they arrived, Corine noticed a very good customer parking his car outside. Keeping a close eye on him, she beckoned him to come over before setting about his business, giving him a little wave. While chatting, she discovered that he was looking for a present for a friend, the director of a major French company. Presenting him with a Sac à dépêches briefcase and a wallet, she immediately caught on that he had something more original in mind. Her thoughts flew to the flask; it was worth a shot. Without showing it to him, she began describing it in detail: the history behind the model, the intricacies of the glass-blowing, the rarity of the piece. Finally, the customer had had enough:
'Do I actually get to see it?'
As he turned it carefully in his hands, his admiration was manifest.
'How much?'
'How much do you think?'
'Thirty thousand.'
'Spot on.'
'It's perfect. I'll take it.'
As he was about to pay, Corine told him the good news:
'Actually, you've got a good deal. It only costs twenty-five thousand francs. It's such a shame you're giving it away, I know how much you appreciate refined pieces.'
'You're right. I'll take the other one as well.'
The subtleties of the art of sales are beyond the grasp of many.

An American Drinks Cabinet

François's* father, Henri Manalt, a well-known figure in the leather goods department for almost fifty years, was the person to go to for placing bespoke orders. This agreeable man, much appreciated for the semblance of an actor about him and his literary turn of phrase, was a gifted listener who knew better than anyone how to help customers articulate exactly what they required. When asked about his career, he recalled with sheer delight the day Sammy Davis Jr. walked into 24 Faubourg in the 1960s, causing quite a stir with his considerable and flamboyantly clothed entourage, most likely his musicians, dancers and vocalists. Having purchased some items, the renowned entertainer had an idea: he wanted a special type of case, a survival drinks cabinet to take with him on tour. 'The case was made from black crocodile skin on the outside and red Morocco leather on the inside, and crafted with the greatest care. The interior arrangement would have sent sommelier cups reeling. Bottles of Schweppes rubbed shoulders with a 1930 Château Margaux, a bottle of Bourbon and two Coca-Colas. A silver-gilt military mess cup and a sandwich box completed the eclectic composition.' Reminiscing, Mr Manalt added with a charmed smile: 'We met again four years later. He must have been pleased with the cabinet because, thanking me once more, he kissed me on the cheeks.'

* Also a sales assistant at Hermès, see 'Finely Tuned Advice'.

For The Last Time

Jacques Le Prévost, a sales assistant at Hermès for thirty years, recalled feeling very moved by one particular customer. He first met her when she asked for his advice about the purchase of a lizard-skin bag. Obviously feeling the need to justify the expense, she said: 'I've just inherited a little something.'

From time to time over the next couple of years, the lady would turn up at the shop to buy a bag.

One day, she said to the person who normally served her:

'That's that. You won't be seeing any more of me. I've spent the lot.'

She never returned.

Touched by Grace

The 'women's bag with straps' was originally a travel bag ranging from twenty-seven to fourteen inches in size.
When flying became commonplace, its popularity soared among female customers, one of whom was the actress Grace Kelly, Princess of Monaco. One day, the Princess used her bag to shield the early signs of her pregnancy from the view of inquisitive journalists. The photo was seen the world over and largely contributed to the success of this practical little case perfectly suited for holding all kinds of personal belongings. Such global publicity created a craze that sent the little strap bag packing. Leaving travel cases behind, it joined the high-ranking ladies' handbag department, and took the name of 'Kelly'. They say that the assistants who sold the handbag would let slip to young mothers that, if required, it could carry a baby's bottle. Of course, we will never know if Princess Grace used hers for that purpose. After all, the Kelly is a bag with a lock.

A Question of Diplomacy

One evening in 1979, Francis Norbert, a leather artisan who had been working at Hermès for ten years, was struggling to fix his moped in the car park when Jean-Louis Dumas appeared. It was late and the vehicle refused to start. Spontaneously, the director walked over to him:

'Still here at this time of night? Would you like a lift? No? Are you sure? By the way, have you seen the job offer? We need someone for the leather workshop in Japan.'

Francis applied and was chosen for the job because, according to him, being single meant it was easier for him to adapt. He packed his bags and settled in the Land of the Rising Sun where Hermès was flourishing.

Once there, he mainly dealt with repairs, ensuring worn down items were given a second lease on life. He also gave leather stitching demonstrations at the thirteen points of sale across the country. These events fascinated the Japanese, whose heritage of fine craftsmanship made them so appreciative of masterly techniques and accomplished work that they would even examine the saddle stitch under a magnifying glass. Often on the move, Francis was featured on television and in advertisements. People even recognised him on occasion in the street, asking for his autograph, which he admitted sometimes went to his head.

One day, the Empress of Japan asked Hermès to cut the strap off one of her handbags. Francis was adamant: complying with this request would completely alter the bag and detract from its appearance. So, he did the unthinkable: he stood up to the Empress of Japan. What a dilemma! Frantically, Hermès sought an honourable way out of this diplomatic faux pas. Having listened to his craftsman's arguments on the phone, Jean-Louis Dumas agreed that the refusal was justified and had another bag sent to the prestigious customer, but one without straps of course. In matters of leather and diplomacy, fine craftsmanship can put anything right.

My Kingdom for a Barrow!

As with many tales worth telling, this one, which took place in 1949, has several versions. Some say the Duke of Windsor commissioned Hermès to make a gift for his wife; others insist a generous guest was looking for something exceptional to offer Wallis Simpson as thanks for an invitation to the Riviera.

Émile Hermès suggested presenting her with a beautiful selection of gloves.

'Not gloves. She has enough to fill a barrow!'

To which Annie Beaumel, who was frequently consulted on such matters, promptly replied: 'Well, give her a barrow to keep them in.'

The idea caught on. The barrow, enhanced with flowers and bottles of perfume, would be used to store the gloves, but its design would be highly original. The task of making the barrow fell to Marcel Lobé, the head craftsman of the *Trousses* workshop. Having bought a medium-sized barrow made of wood, Mr Lobé dismantled it, sanded it, then bound it in black patent leather, which he stitched by hand with yellow silk thread. He coated the rim and axis of the wheel, as well as the tips of the legs and handles, with gold plate before dividing the main body into two separate parts. The front façade was transformed into two antique-styled drawers with gold-leaf handles and filled with bottles of perfume, whereas the rear section was adorned with sumptuous flowers. A space was to be left in the middle

for the gloves themselves. Everyone agreed that it was an object
of great beauty. The story goes that the guest, determined
to travel alone with this masterpiece to the Riviera, reserved
an entire train carriage for the trip.

On arrival, the gift aroused such admiration that
the Faubourg soon received several requests from customers,
begging Émile Hermès to design them a similar model.
He declined politely, but firmly. The piece was one of a kind
and would stay that way.

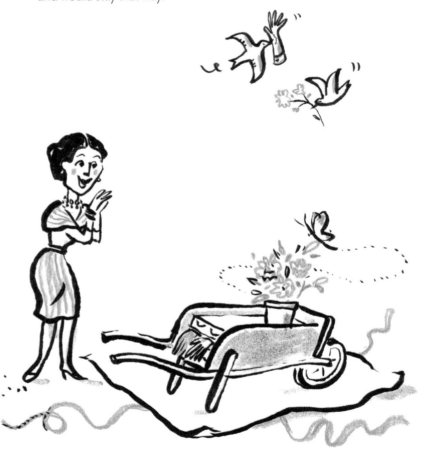

As the Shaving Falls Away

Aged only eleven, Bruno Aimes already knew he would be
a jeweller. As a teenager, his mother entered him for
the cabinet-maker exam at the École Boulle for fine arts and crafts.
But wood did not inspire him – it was metal that sparked
his imagination. After studying jewellery craftsmanship in Paris,
he joined a workshop run by a moody hulk of a man
weighing over twenty-three stone, an artist of sorts who was
as creative as he was reckless. Manuel, a taciturn Spaniard
verging on fifty with a filthy character but fabulously deft hands,
was one of his craftsmen. It was Manuel's immense talent
that left Bruno in no doubt as to his choice of 'master,'
the craftsman's hot temper and obnoxious manner
notwithstanding. One morning, Bruno decided not to budge
from Manuel's workbench; he would learn by watching him.
The Spaniard responded by laying down his tools and folding
his arms. For a whole day, each glared at the other, sizing
one another up. Evening came and Manuel finally gave in:
'You're as stubborn as they come. I'll take you on.' And so,
Bruno began his training. Communication was confined to 'Look,'
or 'Come here: that's wrong, start again.' A compliment was
out of the question, but if he was lucky, his mentor would correct

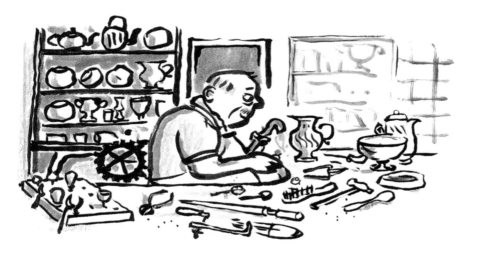

his work without uttering a word. Gradually, they formed a duo,
fashioning wonderful pieces for shops in the Place Vendôme.
Then, in the 1980s, Manuel returned to Barcelona with his life's
savings to invest in his dream: a garage.

Helped by the president of the Jewellers' syndicate, Bruno
secured an interview at Hermès shortly afterwards.
The manager of the leather department, Mr Kermann, received
him with great courtesy and affability, shaking him warmly by
the hand then introducing him to the head of personnel:

'I presume you are a relation of the family, Hermès not being
a common name.'

'I beg your pardon? My name is Aimes.'

There was a distinct air of unease. The secretary had misheard
and written Hermès instead of Aimes. Bruno thought
he would simply be asked to leave, but finally Mr Kermann said:

'We'll give you a two-week trial.'

Before Bruno joined the company, the distinctive style of
Hermès jewellery was sobriety and simplicity of form. 'It was very
interesting. Provided I never lost sight of the pure lines and models
of the workshop, I was relatively free.' When he came up
against a problem, he took evening classes in modelling, sculpture

and metal engraving; and if a particular piece required it,
he would hunt for special tools over the weekend.

Among the experiences throughout his career, his travels made
the deepest impression on him. Sent by Hermès to study
the techniques of the Gadia Lohar gypsies in India, he lived
and worked with them in the Thar Desert. Afterwards, he started
a jewellery workshop with the Fulani people in Mali, where
he lived with a family in a hut. Working cross-legged on the floor
and buying his gold at the street corner, he was gradually accepted
by this ancestral caste of ironsmiths and jewellers. Back in Paris,
he worked in the creative department, crossed paths with different
designers and nowadays devises different shapes and clasps for
'petit h'. Having studied hypnotherapy, he set up his own practice.
He is also an avid rower and takes a passionate interest in
the restoration of horse-drawn traps and carriages. But crafting
metal is still what he enjoys most. 'I engrave copper, it's harder
than gold. You chisel straight into the lump of metal, remove
the shavings, then chip down deeper, cutting from the inside.
I love metal. I can spend hour upon hour applying my skills to
a little copper nugget. It's fascinating. You empty your mind
and enter a sort of trance. The sound of each shaving falling away
says it all and hearing it is simply wonderful. With experience,
once you have mastered how to hone, you make larger shavings
and cleaner cuts. It's deeply satisfying. The shavings shine
because the cut is so precise; it's beautiful.'

An Unexpected Visit

One day in the 1990s, an old lady returned from the market with her shopping bag bulging with leeks. Plucking up her courage, she entered the vast lobby of the Ateliers Hermès in Pantin, on the outskirts of Paris, to ask if she could visit the workshops.

'I'm sorry, visits are by appointment only and there's a long waiting list already.'

Thereupon Jean-Louis Dumas appeared. Saying hello to the receptionist, his alert eye fell on the old lady, who looked disappointed.

'Hello *madame*, what can we do for you?'

'I wanted to visit the workshops but it seems that...'

'Come with me.'

Leaving the shopping bag in the cloakroom, Mr Dumas took the old lady by the arm and for the next forty-five minutes, showed her around the leather workshops. At the end of the visit, gratefully thanking her heaven-sent guide, she said, 'Oh *monsieur*, that was wonderful. What is your name? I will write to your director to tell him how very kind you have been.'

'But *madame*, I am the director.'

His anxious colleagues had been searching for him high and low, but in moments like this, Jean-Louis Dumas could forget his agenda entirely.

Hermès' Artisans at Play

There are a thousand different aspects to beauty: touch, practicality, manufacture, colour, use, durability, lightness, elegance, and humour, of course!*

* Objects from Hermès' conservatory.

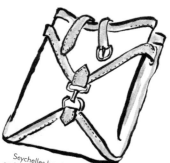

Seychelles beach bag with top and bottom openings to pour away every last grain of sand, 1985.

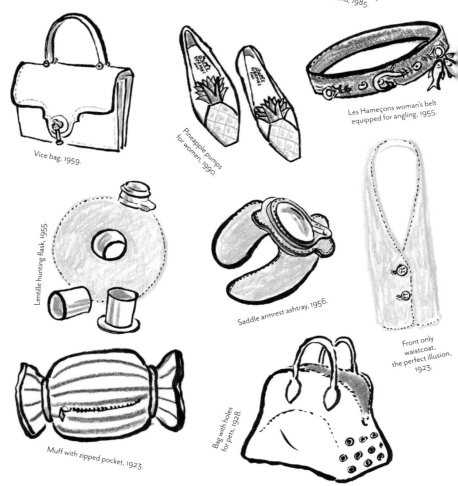

Vice bag, 1959.

Pineapple pumps for women, 1990.

Les Hameçons woman's belt equipped for angling, 1955.

Lentille hunting flask, 1955.

Saddle armrest ashtray, 1956.

Front only waistcoat, the perfect illusion, 1923.

Muff with zipped pocket, 1923.

Bag with holes for pets, 1928.

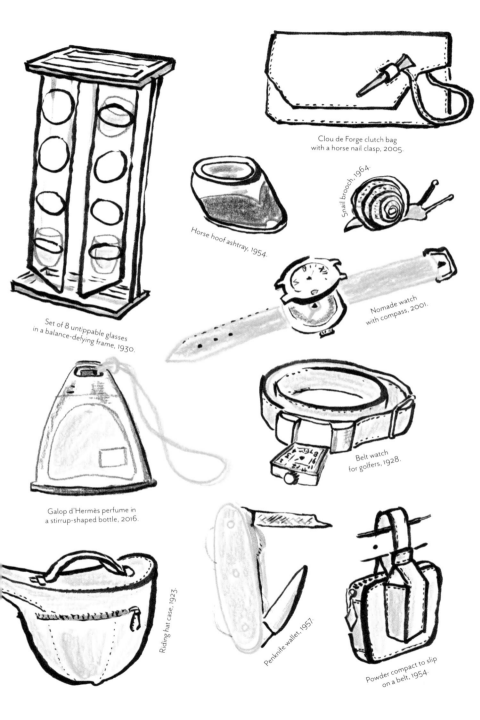

Clou de Forge clutch bag
with a horse nail clasp, 2005.

Snail brooch, 1964.

Horse hoof ashtray, 1954.

Nomade watch
with compass, 2001.

Set of 8 untippable glasses
in a balance-defying frame, 1930.

Belt watch
for golfers, 1928.

Galop d'Hermès perfume in
a stirrup-shaped bottle, 2016.

Riding hat case, 1923.

Penknife wallet, 1957.

Powder compact to slip
on a belt, 1954.

A Dedicated Utopian

In 1964, Dany Delion, the son of a Burgundy farmer and a saddler by training, was hired aged seventeen and a half as a leather craftsman in the *Voyage* workshop. 'I was met at the *rue* Boissy-d'Anglas by the timekeeper, who oversaw the comings and goings and spoke with a strong Pyrenean accent. He provided me with a shared locker, not a personal one, which I didn't think right.' As was customary for probationary craftspeople, his first task was to make a briefcase. 'You've got talent,' he was told once his work had been inspected, to which Dany, a stickler for the rules, remarked that the regulatory trial period had long since come to an end.

A great atmosphere reigned in the workshop where a regularly thumbed photograph album of former colleagues was kept. Dany recalls a craftsman who cut through his tie while working on a piece of leather. The same man found, in the lining of a bag that had been brought in for repair a bone folder made from ivory, a tool he had lost years before. He also remembers an aspiring member of the *Compagnons du Devoir*, the French society of artisans, who spent his lunch hours crafting his *compagnon* masterpiece, a miniature chess set with pieces made of suede, and a party on St Catherine's day at which he recognised an accordionist from his home village. 'Each workshop had something special, but our something was more special than the rest.'

Recruited in 1967 by the CGT, a trade union, Dany became shop steward the following year, then a member of the employee representative committee, a trade union representative and lastly a member of the industrial tribunal. As devoted to Hermès

as he was to his fellow artisans, he dedicated himself to the task
at hand, covering the cabin of a plane in top-grain leather
or making numerous golf bags, sometimes from crocodile skin.
'For me, the most beautiful model was the one with a zip fastener
and a hood entirely stitched by hand, which required strictly
applying a broad range of techniques.' Having honed his skills over
the years, he was entrusted with increasingly complex pieces:
'When you get started on delicate work, your stress level increases,
adrenalin pumps round your body and beads of sweat run down
your spine. But what a sense of accomplishment when you finish
something of beauty. And no matter how much a satisfied
customer enjoys the feel of their newly-purchased bag, the fact is,
I enjoyed it first.'

On his retirement in 2007, this loyal man took an active role
in the association of Hermès former employees, while continuing
to demonstrate alongside his trade union. His overall impression
of his many years at Hermès is one of happiness. He overcame
difficulties when they arose and defended the rights of his
co-workers with discernment and in the name of social progress.
Having believed in an ideal society in his youth, nowadays he says:
'Sadly, there's no such thing as perfect work, or the perfect man.
Nevertheless, I still believe that one day we will live together
in harmony, once greed has been overcome. I might be a utopian,
but I'm not the only one.'

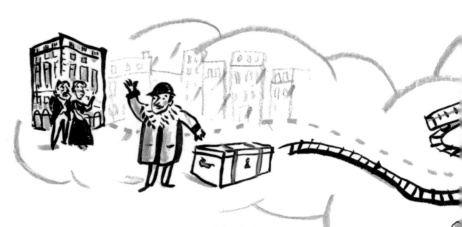

Miniature Models

Hermès was a highly reputed yet relatively small saddler and harness-maker at the end of the 19th century. Seeking to expand its business abroad, the shop set its sights on Tsarist Russia. Aged twenty-seven, Émile Hermès threw his energy into this venture with youthful enthusiasm. After buying a fur-trimmed coat 'out of his own coffers' in order to reassure his parents, he embarked on his first journey across Europe in 1898, armed with a precious notebook containing the names of aristocrats and public figures to contact upon arrival. The enterprising young man returned triumphantly from his adventures waving in one hand a blue silk hat worn by coachmen serving the tsar, and a book crammed full of orders in the other.

Raymonde Ottaway, a former employee, was told the following anecdote by her father-in-law, a second-generation saddler at Hermès: 'Many years ago, before my time, Mr Émile Hermès frequently travelled to different countries. He left with a trunk made of leather, obviously, and filled with miniature models of Hermès tack to present to potential customers. On his return, the craftsmen worked flat out for months on end to keep up with the new orders. But all this was before the First World War!'

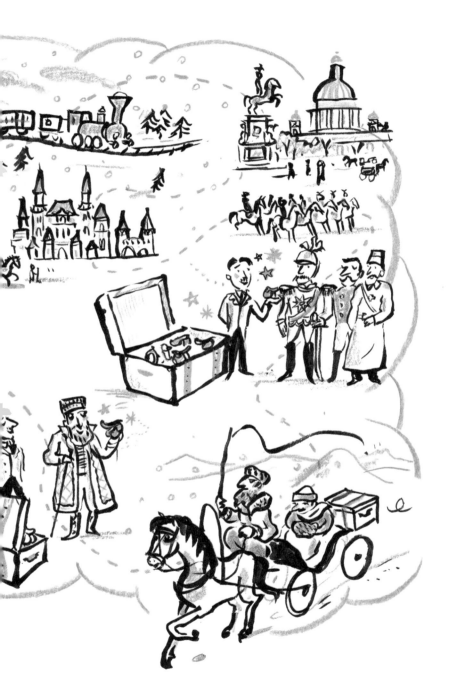

A Lesson in Zen

The son of a Buddhist monk withdrawn in a Zen monastery, Genshi Asakawa attended a private school in Tokyo run by Catholic priests. There, he learned French, was awarded gold stars for good work, and once he had enough of them, a picture of France or a French stamp. 'That was my first, and very positive, contact with the French.' After studying economics, he worked for Seibu, a Japanese department store and the exclusive distributor of Hermès products in Japan. In the late 1960s, he was asked to join the purchasing department for up-market brands and was soon sent to Paris to deal with licenses and orders. Hermès, which he visited twice weekly, was his favoured choice. 'I could see that Hermès was different. I've brought along one of their items to show you. It's my diary, which I've been using for the last forty years. It was expensive, but look how beautiful it is still. Hermès taught me humility, wisdom, but above all generosity towards our customers: in a nutshell, it taught me passion. Such virtues are in keeping with the Japanese mindset.'

On returning to Japan, he became an exclusive purchaser for Hermès, a job he enthusiastically undertook for seven years

before leaving his family for twelve months to practice Zen and meditation in a monastery in Yokohama. When he had to return to work, Hermès naturally asked him to run one of the stores, then the sales division for Japan, which he did for several years.

Succeeding his ill father, Mr Asakawa returned to the monastery in 2003, this time for good. He adapted to the Zen way of life, trained to become a monk and observed the community's strict rules concerning clothes, conduct, prayers and everyday rituals. 'My experience managing sales at the Hermès-Japan company stood me in good stead for caring for our followers. In order to sell goods in Tokyo, you must know how to listen to the customers. This also applies at the temple. Our devotees have problems. We must always take time to listen to them attentively and patiently. If required, we give advice. Everyone has their worries; everyone must express them. It's not good for people to keep their fears to themselves. There's no real difference between working at Hermès and living in the monastery. Fundamentally, it's the same.'

Infinitely refined, Asakawa, dressed in his monk's habit, thanked his visitor for having travelled so far and for giving him this chance to reminisce about the past. As she was taking her leave, he asked her, with insistence, to deliver a personal message on her return to France: 'Please tell Mr Dumas: Asakawa will never forget the fond memories of his career at Hermès. They are a spiritual treasure. With all my heart, I wish prosperity and continuity for his family and Hermès, in keeping with the tradition founded on the agile hands of craftspeople and the passion of those who work for the kingdom of Hermès. That is my message. I will never forget, not until the day I die, perhaps not even in the paradise to come.'

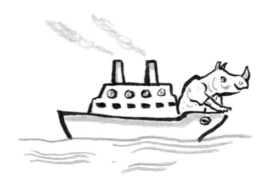

A Travelling Rhino

Taking over from Annie Beaumel, the shopfront priestess whom she had assisted for years, Leïla Menchari instilled in the windows at Hermès a munificent, shimmering and colourful style, creating a myriad of compositions worthy of Ali Baba's cave. In 1978, she devised a display of fantastical animals with, as the star attraction, a rhinoceros inspired by the famous woodcut by Albrecht Dürer. Using a lightweight structure coated with resin, the life-size model was meticulously encased in white ostrich leather and endowed with a gold-leaf horn. A dragonfly on its shoulder and surrounded by fluffy-feathered ostriches and tortoises with red crocodile-skin shells, the advent of Zouzou, as the craftspeople affectionately named it, caused passers-by to gaze in wonder at the majesty of its bearing, the refined grain of its immaculate armature and the effects of the pearly light shining from its nails. Once the display was dismantled, a Swiss collector whipped Zouzou from under Salvador Dalí's nose. Years later, Xavier Guerrand, the grandson of Émile Hermès, was approached by an American customer at an inauguration in Denver, Colorado: 'I bought a building in Switzerland with a rhinoceros which I believe was originally yours. I'd be pleased to return it to you. It's bound to be better in Paris.' The matter was quickly settled. Coveted by shop windows the world over, the fully-booked animal has lived the life of a globe trotter ever since. Recently, it took centre stage in the window at 24 Faubourg once more, having made its début there forty years before. Long live Zouzou!

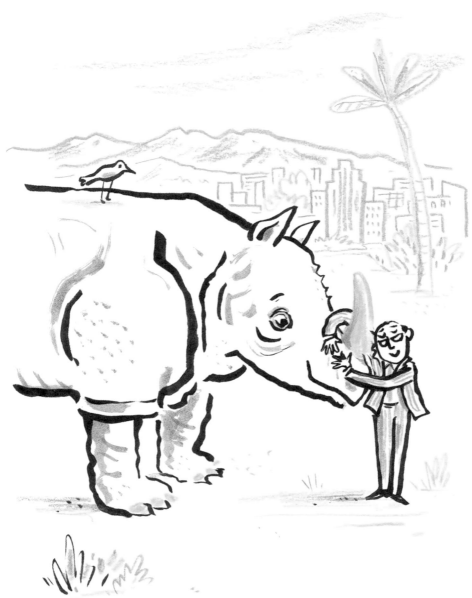

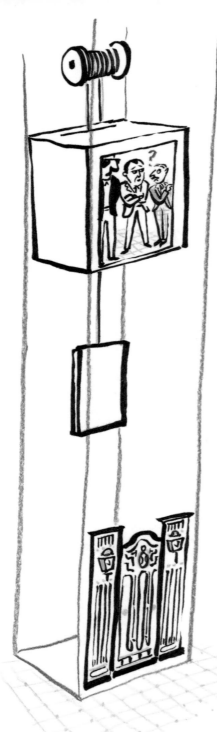

An Improbable Namesake

'It was on a Saturday', Maurice Euzenat, the house electrician and general handyman recalled precisely. There is some discrepancy about the exact year, but sometime in the 1970s, Richard Nixon had come with his bodyguard for a tour of the Émile Hermès collection. Édouard Thil, the most distinguished sales manager at Hermès, was acting as his guide. Dressed in his overalls, Maurice was working in the machine room at the 'Retiro', located in a passageway nearby, when his panic-stricken shop manager burst in shouting:
 'Nixon's stuck in the lift!'
 'Right. So?'
 'So? Get him out! Hurry!'
 'Hold your horses.

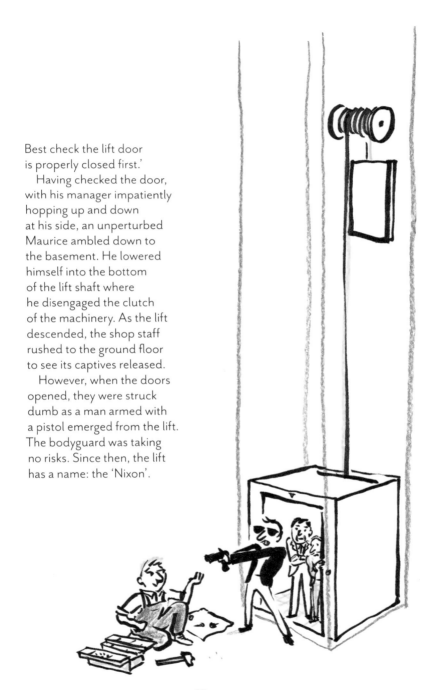

Best check the lift door
is properly closed first.'
 Having checked the door,
with his manager impatiently
hopping up and down
at his side, an unperturbed
Maurice ambled down to
the basement. He lowered
himself into the bottom
of the lift shaft where
he disengaged the clutch
of the machinery. As the lift
descended, the shop staff
rushed to the ground floor
to see its captives released.
 However, when the doors
opened, they were struck
dumb as a man armed with
a pistol emerged from the lift.
The bodyguard was taking
no risks. Since then, the lift
has a name: the 'Nixon'.

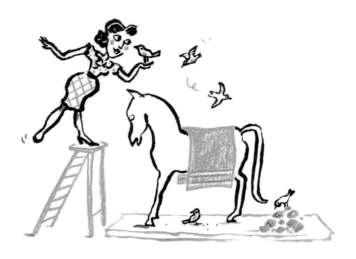

Hustle and Bustle

Annie Beaumel joined Hermès in 1926 and left at the end of the 1970s, but her magical touch lingered on long after her departure. We can no longer tell which outshines the other, her personality or the legend it inspired. Starting off as a sales assistant in the glove department, her many talents caught the eye of Émile Hermès, who soon gave her carte blanche to arrange the window displays.

 With her ability to compose decor out of nothing, or anything, she knew how to create an infinite range of ambience through her unique talent for bringing gloves, bags and clothes to life; arranging the folds of fabrics; hunting out antique furniture; creating a locomotive made entirely from flowers; encasing a horse in feathers; and even borrowing a waxwork statue from the Grévin Museum, which she freshened up with a new haircut along the way. If the window display required her to conjure up a stable, she thought nothing of spreading horse dung over the floor for local sparrows to peck. 'To succeed in my line of business,' she would say, 'you need to let rip with your imagination.' Regarded as curiosities by Parisian high society, her window

displays attracted Cocteau, Dalí, Colette, Jean Marais, Cassandre or even Prévert, who made them an excuse for taking a stroll.

A woman whose silhouette was flattered by her keen sense of dress, she made use of her mischievous blue eyes and finely-tuned cockiness to get what she wanted, proffering 'sweeties' here and 'darlings' there to all and sundry. Thrice married, she was a natural coquette who followed her instincts, not caring two hoots about what people might say. Her impetuous, jaunty character made her the genuine *titi parisien*, capable of switching from devotion to loathing within a few days. A true artist, she was a law unto herself, making her the despot of the window displays, her domain, in which she demonstrated uncompromising perfectionism. Annie knew what she wanted, and what she was worth, and woe betide anyone who got in her way without a cast-iron reason for doing so. On rare occasions, a senior manager dared utter some reservation:

'Could we not...'

'If that's the way it is, I might as well pack my bags and go!'

One of her assistants recounted that in 1952, a curator at the Louvre was so enthralled by her work that he commissioned her to create a display around the *Mona Lisa* for a Leonardo da Vinci exhibition. Having decorated the backdrop with butterflies borrowed from Deyrolle, the renowned taxidermist, Annie Baumel expertly hung a fabric around the painting. The story goes that she then pinned a butterfly directly onto Mona Lisa's shoulder, declaring: 'That livens her up a bit!' When the curator allegedly discovered the desecration, he felt so faint that they almost called for a stretcher.

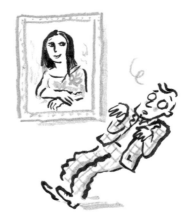

Closely Guarded Secrets

A rather odd craftsman worked in the saddle workshop after the Second World War. At the start of the day, he headed straight for his workbench, without so much as a 'Good morning,' and set about his tasks alone. He took no interest in his colleagues or their craftsmanship. The riding crops and browbands he made were accomplished slowly but with great skill. He alone had mastered special techniques for crafting braided horsewhips, making him a valuable asset for the house, something which had not escaped his notice. Unwilling to share his expertise, he would place cardboard boxes around his bench to shield his work from view. At times, he would even let his fellow artisans make mistakes, though he could easily have intervened to avert them.

Some thought him uncivilised and selfish. He never went to the canteen with the others, preferring to eat a sandwich at his bench, made no effort at conversation during the break and left in silence in the evening. One day, he gathered his things together before it was time to clock off.

'Are you off on holiday?'

'No, I've quit.'

No one had been told, neither his colleagues nor the management. He gave no explanation, but just left without a word.

Refined Horseware

Before becoming a saddlery, Hermès was a harness workshop. In the 20th century, horses disappeared from the streets of Paris, chased away by the internal combustion engine. Hermès nevertheless kept up its bridle workshop, though its staff dwindled to one; Mr Le Souder, bridle-maker by trade, was one of those who passed on this fiercely guarded age-old craft.

Mr Le Souder also made ornate browbands for harnesses, with buffed backs in chequered and diagonally-shaped patterns. But for him, the techniques involved in the rolled-leather double bridle made it the be-all and end-all of his trade. The leather is cut out flat, scored to embed the stitching, then filled with yarn to give it a rounded shape. It is dampened for sewing, then scraped, dried and polished. The stitching is hidden and only a trained eye can make out the perfect line of the seam. On a horse, it makes the double bridle look 'somewhat more refined,' according to Mr Le Souder.

On his retirement, Mr Le Souder gave his successor the same tool he had received from his predecessor: a very sharp, English-made edge creaser to score half-way through the thickness of the leather. Men come and go, but tools and craftsmanship remain, passed down from one generation to another.

Off the Cuff

Aphorisms for people
who make use of their hands.

'It takes practice and repetition
to improve, and that's the point.
Then it just comes naturally.'

'For work like ours,
you have to do it to know if
it's right for you. It's the work
that decides, not you.'

'You work with your head, but use your body, particularly your hands. You must crease edges, polish to perfection, forcefully crush the thread and not burn the leather.'

'We give back what we've received. If we don't pass on what we know, then what we know will come to an end. For me, there is no end.'

'Working with leather is like working with a horse. You have to learn to guide it, to make it do what you want, then you can transform it into something beautiful and elegant that lasts a lifetime, if not more. It's magical.'

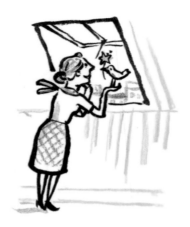

Fortitude and Perseverance

Originally from Saint-Jean-de-Luz in the French Basque Country, Reine Estel was thirteen in 1920 when she began an apprenticeship at Laffargue, a company which had specialised in making small leather goods and studded bags since 1890. After twenty years, she finally became a fully-fledged craftswoman; but on the day of the Normandy landings, both her bosses, of whom she was very fond, were randomly picked up by the Germans and deported. Reine found herself alone and without a job, so she tried her luck in Paris where she stayed with a chamber maid, a family friend who made room for her in her home on *rue* Condamine. 'She treated me better than a sister,' Reine used to say, her gratitude undiminished by the years.

As Hermès had often been mentioned to her in the Basque Country, she decided to make it the purpose of her trip. The day she presented herself at the leather workshop, the foreman was ill, so she was met by the manager who showed her round. Later on, she understood that some of the staff had not taken kindly to this personal tour. 'I was frowned upon from day one, which made it very difficult for me to fit in, extremely difficult in fact. They thought that since I'd come with the boss, I'd tell him everything, and the last thing they needed was a snitch in the workshop.'

Reine was not a trade unionist and did not necessarily share
the same political views as her colleagues, who thought
her bigoted. So, at first, when it came to pay rises, the foreman
passed her by, even though her fingers were no less nimble
than those of her colleagues. This troubled the manager
of the leather department who asked whether she might like
to change jobs. But she was having none of it, saying: 'You really
think I travelled five hundred miles just to give up my job?
No, I chose Hermès, just like you did, and I'm staying.'

Fortunately, the craftsman who worked next to her,
Jean Mauriange, who could neither speak nor hear, became
a close friend. 'He had a sixth sense without a doubt. He cottoned
on to things long before we managed to work them out.'
As the years rolled on, her colleagues grew to appreciate her.
With no ulterior motive but to offer her help, she openly shared
her expert knowledge: 'I would teach everything I knew to anyone
interested.' Then, in her spare time, she darned women's stockings,
making friends with staff from all over the store. Urged to try her
luck, she even plucked up her courage to enter the *Meilleur
Ouvrier de France* competition for skilled craftspeople, where
she featured among the winners, before being informed by letter
that she had failed by one point. 'Well, that's life,' she said
philosophically.

'I did a bit of everything in the leather department. I sheathed
umbrella handles in leather and pipe bowls when the wood
was flawed. With my partner on the workbench, I encased two
hundred and fifty cherry plum liqueur flasks with green leather
dotted with holes for monitoring the level of the liquid, a special
order from Alsace. That meant meticulously cutting, piercing
and gluing the dampened leather onto the bumps and dips

of the flask. Lastly, a separate piece was added to the bottom with the brand stamped in gold. I sewed countless coin holders and folding Zoulou wallets, not to mention watch straps which travelled the world around the wrists of their owners. Diaries, I made those as well, big ones and small ones. I would sit all day squeezing the heavy sewing clamp between my knees. By evening, I could only hobble.'

Reine never married but had a few good friends, as well as her family in the Basque Country with whom she was regularly in contact. She took pride not only in her long-service award, which she received in 1975, but in her fifty-four years of solid work without a day's absence or sick leave, spending her holidays at home in order to put aside her money. She finally bought a flat on *rue* Lemercier, a former slum which she made into a pretty home by dint of scrimping and saving: 'I was never one for extravagant clothes, but I always dressed correctly. Cleanliness, that's what mattered to me most.' When she retired in 1976, the same manager whom she met on her arrival after the war summoned her to say: 'Ms Estel, you are someone who will be truly missed.' After her departure, Reine finally let herself have some fun, taking part in all the travel perks offered by the employee representatives committee until she was very advanced in age. 'I have Hermès to thank for my livelihood, and I certainly made the most of it.'

A model of fortitude and perseverance, she had a firm idea about the source of her inner strength: 'I've got a happy disposition. The hardships in my life no doubt moulded my character, but I've always managed to stay cheery. I've never cared about little things, that's just the way I am. I mean, when you've got what you need to live and be happy, why fuss about anything else?'

Quite a Performance

S porting his distinctive large-brimmed hat and white scarf, Sacha Guitry always made an entrance at 24 Faubourg. Delighting in beautiful objects, the renowned man of the theatre spent lavishly, but often on credit. Reputed therefore as a good customer and an incorrigible debtor, a sales assistant ostensibly avoided him one day by snatching up two suitcases to look busy. Holding back his wife by the arm, Guitry immediately quipped: 'Leave it Jacqueline, the gentleman's off on a trip.'

When his arrears were discreetly brought to his attention, he threw back his scarf with a theatrical gesture, exclaiming loudly, 'Gracious, I had no idea Hermès was short of money!' Another time, when asked to pay upfront, he replied: 'Upfront? "Affront", wouldn't you say?', with which he turned on his heels discarding the jewel he had just selected. And on it went for years, providing the master dramatist with an opportunity to pronounce one of the witticisms for which he was so well known.

As Émile Hermès was pointing out the many attributes of a new handbag, Guitry suddenly interrupted and, addressing his wife at that time, said in a loud voice: 'Jacqueline, come quickly. Obviously, Mr Hermès intends to give you the bag.'

Like a Glove

Some wear them, others do not. Enveloping, warm
and a godsend at times, gloves are an accessory,
but necessary. Ms Rivière was hired by Émile Hermès in 1934
to run the glove and scarf department. She explained
that before 1930, Hermès only made and sold traditional gloves.
They were long and short, some buttoned and some with
straight-forward designs, made from antelope, Lapland reindeer,
Arabian gazelle, refined suede, and more. Sporting models
followed, fashioned for different activities: skiing, riding, golf
or driving. After the war, the creative originality of each
new design largely contributed to the renown of the Hermès
glove, the elegance of which was greatly sought after
by an international clientele.

'They were all stunning! The list would be long!'

Ms Rivière remembers them all, but picking out some of her
favourites, she recalled black suede gloves with large
hand-embroidered cuffs fringed with silk; a light-mauve pair
lined with grey mink; short white kidskin gloves, one model
with *plumetis* stitching and another with small embroidered fruits
above the nails; gloves with an embroidered band and an
accompanying scarf in the same pastel-coloured all over print;
short gloves with rounded mirrors on their backs; gloves
sewn with different coloured silk thread around the thumb;
a short model adorned with a small dog's collar made of badger
fur and a ring-shaped clip; and a last pair with a woollen

cloth infused with perfume. She remembers gloves made specially for the theatre, for celebrities, for sports champions, and even for the Pope.

It was around this period that Annie Beaumel devised her 'window display of famous hands', using mouldings from Sacha Guitry's personal collection. Featuring in the display was a remarkable achievement – an ostrich leather glove folded in a walnut. *Quel chic!*

In the Saddle

Regardless of whether you rode horses or not, listening to André Broquère speak about his work captivated your attention and opened up a whole new world.

'I've never hurt a horse with a saddle: the horse comes first, not the rider. You're dealing with two customers, and the difficult one isn't the horse. Poor horse, he's got no say in the matter. When a customer ordered a saddle, I asked: "Is it a wide horse?" "I don't know." So, I'd go see for myself. I had a pencil and a measuring tape three feet long and an inch wide, which I placed halfway up the horse's withers. Then I'd gently trace the animal's shape onto paper, along the dip of its back, following its spine, which we'd later retrace to make the padded leather panels for the saddle. If the horse was round and the withers weren't visible, which can happen, the panels had to be slimmer for the saddle to sit closer to its back. It's all part of the job. After that, I enquired about how the customer sat in the saddle. Astride the model horse, we'd ask him to move to the highest point in the saddle, the furthest back, then forward, to make sure it fit. We also asked whether he required front or back blocks and side bags. There were dressage saddles and jumping ones with neither cantles nor flaps, in order to highlight the rider, not the saddle.'

André Broquère enjoyed talking about the trade he had practised for decades at Hermès, but also about his adventurous youth. 'My life is like a novel,' he said in 2003, aged ninety-four. The twelve-year-old boy who dreamed of becoming a doctor

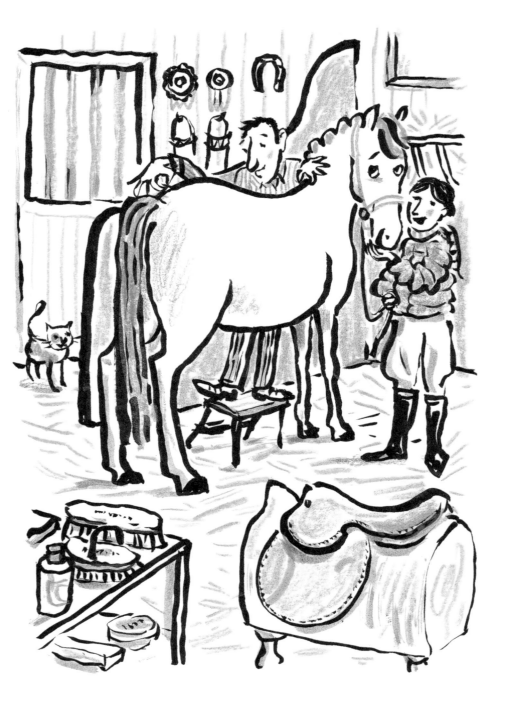

was put into a saddlery apprenticeship by his father,
a day labourer in Margaux, a town in the southwest of France.
After three years of hard toil, he obtained both valuable
experience and a worker's certificate. One day, he came across
the *Compagnons du Tour de France*, the renowned society
for craftspeople, which was recruiting in the area. Slinging a bindle
over his shoulder, he set out on foot, by bike and by train,
embarking on his tour of the regions of France, in order to become
a *compagnon* himself. Receiving lodgings, but not always board
from his artisan hosts, he described a life of slavery, bedding
down in insalubrious hovels, even crying from hunger at times.
Using his body weight to make horse collars, a dip formed in
his sternum: 'At that age, your bones are still soft, it never filled out
again.' He did write a diary of his journey, but it all seemed
so unbelievable that he eventually threw it away.

Despite the hardships, he would have done it all over again.
Assigned to a saddle workshop for his National Service,
he fulfilled his obligations, then continued his journey, travelling
to Normandy, Brittany, the outskirts of Paris and Lyon,
the Dauphiné region, Provence and the French Riviera, working for
around thirty different workshops. Throughout his trip, he heard
about the superior quality of the Hermès saddle. So, in 1933,
he tried his luck. But the timekeeper told him that there
was nothing on offer. A few years later, in a restaurant in occupied
France, he met Jean Guerrand, a son-in-law of Émile Hermès.
Taking an interest in the *compagnon* meeting to be held in
the next room, Mr Guerrand pulled up a chair, talked a while,
and hired him on the spot. In the saddle for a new chapter
of rich and tireless work, André Broquère tackled it with gusto,
subscribing to the society maxim:
 'Believe in it, love it, do it well.'

Then this indisputable master, award-winner of the *Meilleur
Ouvrier de France* competition and admired *compagnon*
with eighty years' experience in the trade, added a final comment:
 'They say you're judged by the flowers on your grave,
but in fact it's people who judge you. I'll tell you something,
at Hermès, I think I did myself proud.'

Finely Tuned Advice

A famous guitarist was paying for his various items at 24 Faubourg, when the sales assistant, François Manalt, was struck by a pertinent idea and suggested discreetly:
'I think you may have forgotten something.'
'And what would that be?' enquired the rock star, curiosity having no doubt got the better of him.
'Well, a guitar case.'
But the legendary guitarist appeared uninterested and took his leave politely while Mr Manalt returned to his daily business.
Scarcely twenty minutes later the musician reappeared, a smile on his face and a guitar in hand, having fetched it from his hotel. The idea had struck a chord; one case would not do, he needed three. There and then, he was shown upstairs to meet the craftsmen in the workshops. Something just clicked between that dexterous strummer of strings and those nimble masters of needle and thread. So much so that the famous musician reached for his guitar, likely at an artisan's bold request, and improvised a musical interlude before a select circle in overalls, spellbound by the wondrous simplicity of the moment, much like the spontaneity of a surprise kiss.
The first case would be made from matt Havana brown crocodile leather lined with blue crushed silk velvet. The other two would follow the same design but using different materials and colours. Lucky enough to be sent to London by the management, Mr Manalt and the craftsman presented the leather, the samples of velvet, the locks and the nails to the master of blues for his approval, while, and this they never forgot, he made them coffee himself. 'At Hermès, circumstances like those are not altogether uncommon,' François Manalt said years later, his tactful manner barely concealing a tinge of nostalgia.

Kindred Spirits

"I was looking for someone different and when I saw your Noah's Ark exhibition on the Champ de Mars, I thought, "he's the one! He must be totally mad."' Hilton McConnico, in vogue fashion designer, photographer, decorator and set designer for films, was not sure how to interpret this last comment. Jean-Louis Dumas had just approached him about an exhibition on the Émile Hermès collection and he was under the impression that madness would be an asset! Hilton's look of puzzlement prompted the bubbly director to explain further:

'Let me tell you a story: a driver needs to repair a flat tire. He puts the hubcap and four bolts on the ground, but a truck drives past and scatters them out of view. Not quite sure what to do, he notices two men sitting on a wall at the side of the road. One of them suggests he take a bolt from each remaining wheel and fix them onto the spare one. Just as he is leaving, the driver reads 'Mental Asylum' written in capitals on the wall. "Great! Thanks for your help! But what are you doing here? You're not lunatics?" "Yes, we are! We're barking mad, but not stupid."'

Though Hilton could not have guessed that the natural affinity between them would last for nearly two decades, he knew in a flash that he had made a friend for life.

For years both men delighted in enchanting and amazing when it came to organising exhibitions based around the crafts

of Hermès, all the while outrivalling each other's boundless
imagination. Each decor was imbued with fantastical
imagery, which would pique, and at times even gently challenge
the erudition of onlookers. Hilton McConnico used to say
that illusion was grounded in trust; in order for the magic
to operate, the spectator must be left no room for doubt.
His was the task of awakening the child within each of us,
longing for wonder and conjuring tricks. And to create
the perfect circumstances to cast his spell, he was given entirely
free rein, which he used to the utmost effect. *Carnets de voyage*,
McConnico's exhibition in Paris in 1988, gave rise to room
after room of walls swathed in shot silk, presenting a life-size
horse made of wire in a small castle; a porthole looking over
an undulating sea; Venice reflected on glass paving;
and a dummy dressed in a kimono in front of a saddle
embroidered with exotic fish. A send-up of Darwin brought
the exhibition to a close: at the end of a long corridor,
holding the leash of a rat coiffed with a finely-curved feather,
stood a female monkey in an 18th century-styled pink
and white damask silk dress, contemplating with absorbed
interest a painting by Delacroix.

Humankind may share an ancestor with the ape, but some
artists share theirs with a mischievous monkey.

A Stylish Impression

enri d'Origny is a legendary figure at Hermès. As the creator of numerous famed scarves; an excellent horseman in his hours of leisure; the designer of timeless classic watches, such as the Arceau and the Cape Cod; the almost unwitting inventor of motifs that forged the style of the Hermès tie; and a veteran of 24 Faubourg with more than sixty years of service, he deserves an entire monograph to himself. All that notwithstanding, his career began with a flop, or so he said.

His teenage years were spent at the same renowned boarding school as Patrick Guerrand, the grandson of Émile Hermès. Having a natural flair for the arts, rather than academia, the young Henri was introduced by Patrick to his uncle, Robert Dumas, who was responsible for scarf designs and whose expert eye appreciated the many qualities of the young man's drawings. Henri was given the chance to submit a design for a scarf and tasked to draw inpiration from the Émile Hermès collection, the famous third-floor museum. There, his attention was held by hunting knives and a stag's head made of bronze: the majesty of the animal, the lure of the hunt, how could he go wrong?

After sweating blood and tears for two long months, the nervous young candidate presented his work with a pounding heart. 'Quite brilliant! What extraordinary talent!' said Robert Dumas. 'Of course, we can't possibly use it. First, one should never give knives, they sever friendships; as for antlers, horns actually, they symbolise adultery, cuckolds to be quite frank. Do hope you understand; it would meet with outright disapproval. So, that's that! Into the bin and back to the museum.'

On scrutinising a rare Renaissance book with illustrations of different spurs and bits, these equestrian mouthpieces sparked his imagination. At length, he presented the candid director with Mors et Gourmettes, 'Bits and curb chains', a scarf that would meet with resounding success, even to the present day. On their knees in the director's office, they worked for hours on end finishing the original model, a process they applied to each of his future creations: correcting, matching, altering, sticking and snipping. But then, he had been warned: *'Vingt fois sur le métier, remettez votre ouvrage.*'*

* 'Put your work twenty times upon the anvil': Nicolas Boileau, 17th century French poet and critic.

77

Memory Game

Do you remember where you came across the following objects, which were mentioned by the passengers on the Hermès odyssey?

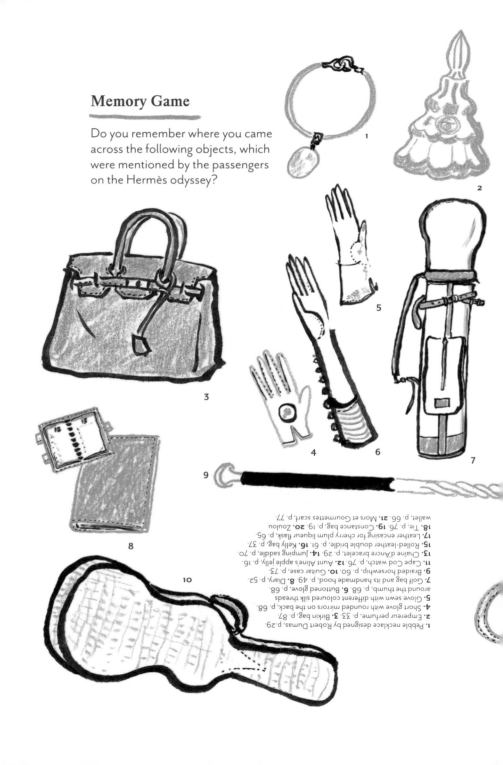

1. Pebble necklace designed by Robert Dumas, p.29.
2. Empereur perfume, p. 33. 3. Birkin bag, p. 87.
4. Short glove with rounded mirrors on the back, p. 68.
5. Glove sewn with different coloured silk threads around the thumb, p. 68. 6. Buttoned glove, p. 49.
7. Golf bag and its handmade hood, p. 49. 8. Diary, p. 52.
9. Braided horsewhip, p. 60. 10. Guitar case, p. 73.
11. Cape Cod watch, p. 76. 12. Aunt Aline's apple jelly, p. 16.
13. Chaîne d'Ancre bracelet, p. 29. 14. Jumping saddle, p. 70.
15. Rolled-leather double bridle, p. 61. 16. Kelly bag, p. 37.
17. Leather encasing for cherry plum liqueur flask, p. 65.
18. Tie, p. 76. 19. Constance bag, p. 19. 20. Zoulou wallet, p. 66. 21. Mors et Gourmettes scarf, p. 77.

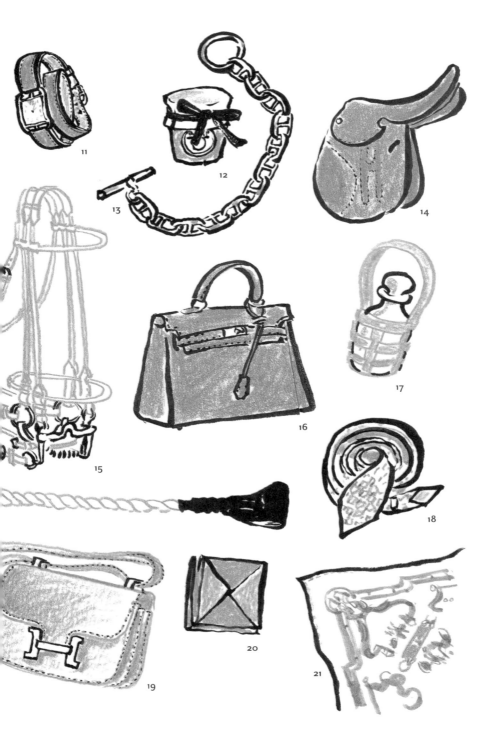

11

12

13

14

15

16

17

18

19

20

21

An Édouardian Gentleman

'**M**r Thil's presence is requested': whereupon the debonair, distinguished and self-assured Édouard Thil would appear to greet his regular clientele with a charming English accent. An aura of mystery surrounded his earlier years, his perfect command of the English language being a matter of some speculation. Had he lived in London during the war? Did he previously work for a British travel agency? Or had he perhaps served on the Orient Express? In private, it was common knowledge that he had been born to French parents in Colombes, a suburb of Paris, and that this English persona was pure invention. Be that as it may, everyone at Hermès played along. This former jockey of elfin build would still, in his prime, train racehorses at dawn before a full day's work at the helm of the saddle department.

Édouard Thil excelled in the art of hospitability and met even the most original of his prestigious customers' requests. Assisted by the shop's manager, Mr Fontanet, he literally rolled out a red carpet for the Count of Paris and, in order to shield the Shah of Iran's fiancée from the indiscreet gaze of onlookers, he unfolded screens throughout the store when she came to be fitted for clothes. For him, the greatest cause for outrage was a shabbily dressed customer. Indeed, in the late 1970s, he almost fainted at the sight of a lady entering Hermès in a fur coat and Moon Boots. Frightful!

Donning a tweed cap in place of a helmet, he drove an old moped, a handy device to scoot the wrong way up a narrow street. True to his idiosyncratic style, he had the doors of his navy blue Ford Fiesta emblazoned with his monogram in gold letters, as was

customary on horse-drawn carriages of old. He preciously preserved his gloves and shoes by never wearing the same pair two days in a row, firmly advising sales assistants fresh from school to follow in his footsteps. But behind the scenes, his impeccable shop-floor manner was dissipated by his sense of fun. He loved a practical joke, even letting the sales staff lock him into a window display, his hard collar and upright demeanour making him the perfect waxwork model. Unfailingly, he drank a cup of tea late in the afternoon, from which sometimes emanated – for different times, different customs – an unmistakable whiff of whisky. During one of those rituals, he tantalised a newcomer whose name he had conveniently Latinised, saying: 'Dominicus, do you know who is the most beautiful woman in the world? Let me show you the most beautiful woman in the world.' Picking up a magazine he handed it to the young man who discovered, spread across a full page, a photo of Her Majesty the Queen.

Sometimes, when accompanying customers to the upper floor to have them fitted for a custom-made saddle, he became pernickety about the position they adopted astride the model horse. This tendency considerably irritated Mr Broquère, the head saddle-maker at the time. One day, losing his patience, he burst out:

'Mr Thil, there's no right position for doing it, and there's no right position on a saddle.'

'Gracious me! Mr Broquère!'

An Extra with an Extra Something

André Chacon was Spanish on his father's side. A former
Castilian champion of bare-handed Basque pelota,
his father had learned French at a Jesuit school in Madrid,
André's grandfather having been persuaded of the importance of
a good education by a famous cardinal for whom he worked
as a cabinet-maker. André's mother, though French, had been
brought up immersed in Native American culture because
of her father, who had run various businesses, including an apple
farm in Vermont. With only a smattering of English, he spoke
perfect Latin, a lingua franca he shared with the American Indian
doctor on the estate, who would then relay his instructions
to the farm labourers. André's mother met her future husband
in Paris where he worked as an interpreter and stenographer
at UNESCO. They later settled in the Oise region of France with
their son. There, the many stories and artefacts her father had
brought back from North America stood her in good stead for
a job as technical consultant for a Wild West theme park.

In the mid-1960s, this park acquired the last working horses
of Paris, those of the ice men who mainly delivered their
cartloads of frozen blocks to restaurants. With the disappearance
of the trade, the horses were destined for the slaughterhouse.
Much troubled by their lot, the society for the protection

of animals intervened, and thus the noble beasts were
saved along with their carts and harnesses. André began to look
after the horses, acting as an extra on horseback in shows and
advertisements out of school hours. Later, he worked as a *gentil
accompagnateur* in Vittel for the *Club Med*, the famed French
holiday company, before driving carriages in adventure films
for stables renting horses, equipment and riders. An extra during
the day, André studied at night to become a qualified saddler,
completing in a single year the two-year course at the Turquetil
school for leather crafts.

Living a stone's throw from the Faubourg Saint-Honoré,
he and his family had often admired Annie Beaumel's window
displays. So, like many before him, he tried his luck one day
with the timekeeper. 'Wait there, I'll call the workshop supervisor.'
Having passed the test – stitching both sides of a Lydie bag's
gusset – he was asked to present himself for hire the following
Monday.

On top of his regular work, he was entrusted two years later
with the responsibility of 'stamping' in the *Malle* workshop.
Stamping involves imprinting 'HERMÈS-PARIS' in hot 22-carat
gold leaf lettering onto finished items, or those being made,
and is also used for all the customised markings, such as initials

or extra embellishments. The stamp's impact alters depending on the type of leather or the moisture level in the air, sometimes causing the mark to disappear. As André later discovered, no one wanted the job, stamping being a painstaking procedure that takes time and represents a heavy responsibility, particularly when undertaken in front of an attentive customer to whom the service has been offered as a special favour. Frequently interrupted to carry out these pressing demands, the person picked for the task is therefore regarded as a bit of liability for their workshop's rate of production.

But André took an interest in stamping and, wishing to improve his skills, insisted on the need for a course in bookbinding. By 1985, he was a qualified gilder. Assigned to the special orders workshop, he was his own master, working particularly for 24 Faubourg as well as different departments and workshops. However, this relative independence sometimes made his position awkward. Irritated by a certain lack of recognition, he ended up talking to his management, saying:

'I may not produce the goods, but my mark makes all the difference. If you want your products to sell, you need an extra something. That's where I come in.'

One day, Jean-Louis Dumas, always on the qui vive, passed by the workshop and, watching him at his work, could not resist a mischievous comment:

'It's not quite straight.'

Wholly confident in the precision of his measurements, André, unperturbed, retorted:

'Anyone can do it straight, but making it even prettier by putting it on slanted, well, that's pure art.'

Not bad for an extra!

Sticking to Tradition

As a young man, André Broquère, known as *Bordelais le courageux* – Bordeaux the Bold – by his comrades in the *Compagnons du Devoir*, received a walking stick. On its knob were engraved attributes relating to his identity: the year he joined the society, 1936, a saddler's round skiving knife, a set square, a compass and some wholly enigmatic acronyms for the uninitiated. Before him, the walking stick had belonged to an older *compagnon*. As a symbol of travel, moderation and rectitude, walking sticks are traditionally handed down to young society members on the day of their admission, but the knob remains with its original owner. On his retirement, it was time for the master saddler at Hermès to pass his walking stick on to a young comrade, Laurent Petit, known as *Rochelais Va de Bon Cœur* – Rochelais the Willing – who would do the same in due course. After Bordeaux the Bold's death, Rochelais donated the knob to the Émile Hermès collection. It now sits beside two miniature collars for draft horses, the *compagnon* masterpieces fashioned and donated by André Broquère himself, on the completion of his tour of France. As for the walking stick, it continues each stage of its journey in the hands of a new master.

Acting on Instinct

The box of chocolates had been left in the fridge... Shortly after the war, Joe Stafford, a young American officer dispatched to Frankfurt, was supposed to have given it to a friend of his aunt's, but he led a busy life and it slipped his mind. One day, the doorbell rang. Standing there, a furious young girl addressed him sharply: 'Where are my chocolates?' She was Anita. A teenager in newly defeated Germany, she had lost track of her parents, fled from the advancing Russians, eaten raw vegetables from frozen fields, suffered fear and cold, and lived through the best and the worst experiences: those of survival.

Joe fell in love with this intense woman and after a while, he married her. They settled in New York where Anita threw herself wholeheartedly into her work. A sales assistant at Bonwit Teller, a department store on Fifth Avenue, she was spotted by Jean-Louis Dumas, who appointed her to run the new Hermès store on the same site. One day, a man stole a leather jacket from the shop. Immediately, Anita grabbed an assistant on the fly and set off in hot pursuit. In true American football style, the two women, gasping for breath, caught up with the thief, tackled him, pinned him to the ground and held him there until the police intervened. 'If he'd been armed, they could have been badly hurt! But Anita always followed her instinct,' sighed her husband, still affected by the incident twenty years on.

A High Flyer

Spacious and supple, this bag is fastened with a discreet clasp on a leather strap. When open, women can search for that vital object with the tips of their fingers, or slip in another of their choosing. When shut, it harmoniously blends in with their silhouettes, artfully holding the treasures concealed within. This highly coveted object, designed by Jean-Louis Dumas, reflects an air of casual elegance upon the woman who carries it. A genuine celebrity nowadays, it owes its existence to a chance encounter.

The vibrant director of Hermès boarded an airplane heading for London and took his seat. Sitting beside him, a woman was rummaging around in her handbag for something she needed for the trip. With some irritation, she tipped its contents onto the floor before turning towards her neighbour. Visibly intrigued by her predicament, Jean-Louis struck up a conversation.

'It would be better with pockets.'

'Oh, handbags, they're simply not designed for modern-day women.'

Surprised and delighted by his good fortune, Jean-Louis Dumas recognised the actress and singer, Jane Birkin.

'Now that's interesting. Tell me, what would you do to improve them?'

And that was the start of a long discussion about the materials, the uses and the size of what would make the ideal handbag. High in the sky, Jean-Louis Dumas had just come across a muse.

A Diary with a Special Role

Popular for its practicality and the exquisite feel of the leather as it ages, the Hermès diary, a great house classic, has always had its fans, many of whom Nicole Lenormand served attentively over the years. The daughter of René Verdet, chief accountant at Hermès, Nicole was spotted by Annie Beaumel as a teenager at the hairdresser's near 24 Faubourg: 'Of course! I know her; she's a Verdet! I'd like to have her if she is free, I could do with someone like that.'

After several years overseeing the magical window displays under the legendary Beaumel, Nicole switched to the diary department, a shop within the shop. Among her many customers, she recalled Philippe Noiret, Jean-Pierre Marielle, Gregory Peck and Yves Montand, who came each year to acquire the precious gilt-edged refills of bible paper. Traditionally made from box calf, a top-grain leather, the diary gradually became available

in a range of different sizes and precious leathers. 'I remember
a very stylish customer always dressed in navy blue,
who regularly bought the small diary, a preferred choice
for the practical-minded, often Americans. One year,
he ordered a custom-made diary in navy crocodile skin together
with a gold pen, which was adorned with a navy sapphire
to match his cufflinks!'

Like many others, Nicole had an amusing anecdote to tell
about a diary with a special role at the theatre. In the 1950s,
Simone Berriau, a former actress turned director of
the Antoine Theatre, received a set of travel cases from a man
who, in all likelihood, felt somewhat disappointed by the nature
of their friendship; for on receiving the bill, he had a change
of heart and only deigned to pay for the cases' keys. To reduce
this unforeseen expense, Ms Berriau came up with an original idea
for publicity, which she put to Jean Guerrand, Hermès' sales
director. And so it was that, during the interval of a long-running
play by Sartre, theatre-goers could hear the following
announcement: 'Your attention please, one of the ushers
has found an Hermès diary. Would the owner of the diary please
come to the box office to retrieve it. Your attention please...'
It took eight months before a mischievous opportunist in
the audience had the nerve to claim it as his own, pocketing
it without a backward glance.

In the Course of Time

'On his retirement Mr Cotelle, a saddler at Schilz, gave me an awl made from lemon tree (or was it orange tree?), the same one his father had given him,' explained one of the workshop's former saddlers. 'Each generation cut its own groove in the wood; mine was the fourth. The tool wasn't worth anything, but it meant a lot to me. When it was my turn to leave Hermès, I gave it to *Petit Bonhomme*. Didier Bonhomme was the fifth generation to receive the tool and the last craftsman I trained. From time to time, I call in at the workshop. He always pulls my leg, saying: "It broke, so I binned it!"'

The Last Dance

'The mysterious workings of a saddle lie in its internal structure, that's the way it is. As for the material, to transform it, you must understand it. It's like dancing a tango. You have to guide it through the dance for it to be elegant and flowing.'
This is how the master saddler, Laurent Goblet, summed up his intimate knowledge of saddlery after forty-two years of craftsmanship. He learned the trade alongside his elders, and in 2020, he finally retired. The previous generation focused mainly on custom-made saddles, for which only natural materials were used. But he began to branch out into jumping and racing saddles, for which foam and carbon were slowly introduced. Some keepers of the flame were not impressed by such a bold move. 'A saddle is like common courtesy, there's nothing to innovate,' Juan Iñiguez used to say. Laurent Goblet does not talk of 'innovation', 'development' is his chosen term. This subtle difference speaks volumes. For him, the ultimate goal is not simply a beautiful saddle, but a highly performing and technical object fashioned specifically for the requirements of the rider. To achieve this objective, he himself tried out his saddles and asked international champions for their opinion.

When the time came for him to leave, like many before him, he experienced a moment of doubt. Did he manage to pass down his expertise and personal techniques? Would saddlery at Hermès maintain the high standards for which it was renowned? On reaching this final port of call, such questions have tormented the minds of many over the last two hundred years. Yet, Hermès continues its odyssey, and sailing the maritime routes of old, changes tack, waters swirling mysteriously in its wake.

Glossary

Saddles and Harnesses

The **browband** is the strip
of a bridle or harness that lies
across the forehead of the horse
below its ears.

The **cantle** is the arched rim
which forms the back of the saddle
and which can vary in height.

The **collar** is the part of the driving
harness that is placed around
the horse's neck and rests against
its shoulders.

The **flaps** cover the sides
of the saddle that are in contact
with the rider's legs.

The **front and back blocks**
are fitted onto a saddle either
in front of or behind the rider's
knees in order to help the rider
sit in the right position.

The **mouthpiece** is the generic name
given to the 'bit', a metallic object
that fits into the horse's mouth
and helps the rider direct the horse.

The **saddle stitch** is stitched
by hand and requires two needles.
Using a linen thread coated in
beeswax, each end of the thread
crosses the other after passing
through the leather. Its great
sturdiness keeps the stitching tight
over time.

Tools

An **awl** is a steel hole-punch with
a round handle used for pre-piercing
leather and guiding the needle.

A **bone folder** is a small, elongated
tool often made from bone. Pointed
at one end and rounded at the other,
it is used to polish and trace lines
on leather when one piece is stitched
to others.

An **edge creaser** is used to make
a furrow in leather, particularly
for embedding stitches.

A **round skiving knife**
is a half-moon-shaped blade used
for cutting and perfecting leather.

Materials, Craftwork and Craftspeople

All over print is a printed pattern,
the motif of which is repeated over
the fabric's entire surface.

Box calf is an iconic calf
leather which borrowed its name
from the 'box' tanning technique.
This specific craftsmanship
gives it a supple and firm feel,
as well as a shiny and smooth finish,
livening up its deep, dark hues.

The *Compagnons du Devoir et du Tour de France* is a French society of craftspeople, the core purpose of which is to train young people in artisanal trades through the traditional mentoring network of its members. People aspiring to join the organisation are lodged and trained by established *compagnons* during their mandatory tour of France.

Guilloche engraving is a series of intertwined and regularly repeated lines etched onto an ornament.

The *Meilleur Ouvrier de France* competition for the best crafstpeople in France is held every four years and covers many different categories of trade. The winner of each category is granted the prestigious title of *Meilleur Ouvrier de France*, or 'Best Craftsperson of France'.

Plumetis is a succession of small, tight stitches, most often applied to light materials, which make a low-relief embroidery.

Schools

The **École Boulle** is a fine arts college in Paris particularly renowned for courses in carpentry, engraving, cabinet making, sculpture, antiques restoration, interior design, upholstery, marquetry, and more.

The **École du Breuil** is the municipal horticultural college of Paris. Created in 1867 by the *baron* Haussmann to train Paris's future gardeners, the school is located nowadays in the Bois de Vincennes in the southwest of the city. Its students are taught horticulture, gardening, landscaping and urban agriculture.

The *lycée professionnel* **Turquetil** is a leather crafts training college in Paris. As part of their training, the students are required to do an internship while following courses at the college. Turquetil is also reputed for its close links to the fashion and luxury goods industries.

Hermès, a Family Affair

Hermès was founded in 1837 by **Thierry Hermès**. His grandson, **Émile Hermès**, headed the company from 1919 to 1951. On his death, he was succeeded by two of his sons-in-law, **Robert Dumas** at the helm and Jean-René Guerrand as deputy director, from 1951 to 1978. **Jean-Louis Dumas**, took over from his father in 1978 until his retirement in 2006. **Axel Dumas**, Jean-Louis' nephew, has been executive chairman of Hermès since 2013.

Luc Charbin

An enlightening and enlightened amateur of history, genealogy and linguistics, Luc Charbin has a taste for well-chosen words and stories retrieved from oblivion. Privy to the secrets of dictionaries and encyclopaedias for a while, he has since made family archives his speciality. His erudite pen has contributed to many collective works including editorials and speeches. *Straight from the Horse's Mouth* is his first publication written under his own name.

Alice Charbin

After studying at Camberwell College of Arts in London, Alice Charbin returned to Paris where she now lives with Luc and their five children. She works for publishers as well as the press and the theatre at times. An author and illustrator of books for readers both young and old, she loves to create a colourful and poetic universe, which is brought to life through the tender humour of her drawings. Having contributed to the Hermès website for fifteen years, her illustrations were compiled into a book, *Hermès au fil des jours* (Chêne, 2019), published in English as *Hermès: Heavenly Days* (Abrams, 2020). Her latest publication, *Rita sauvée des eaux*, came out in 2020 (Delcourt). She also happens to be one of the many great-grandchildren of Émile Hermès.

Acknowledgments

Luc Charbin wishes to thank Hermès for having entrusted him
with its archives of staff interviews. He is deeply grateful
to Menehould du Chatelle, Nathalie Vidal and Lan du Chastel,
who generously gave their time and knowledge to help
his candle glow brighter when he lost his way in the labyrinth
of these abundant memories. He also thanks all those
who agreed to feature in this work. Lastly, thank you Alice
for having livened up the pages of this book with your vivacious
and light-hearted illustrations.

Alice Charbin wishes to thank all those who shared memories,
opened doors, suitcases and treasure troves, and helped make
this book possible.

For the French Edition:

CEO: Emmanuel Le Vallois
Editor: Sabine Houplain
Graphic Designer: Prudence Dudan
Editorial Operations: Louise Noblet-
César

Originally published in France by:
© Éditions du Chêne – Hachette Livre
in 2021

Translator: Hazel Duncan

Library of Congress Control Number:
2021946857

ISBN: 978-1-4197-6259-8

Printed and bound in Italy
10 9 8 7 6 5 4 3 2 1

Abrams® is a registered trademark of
Harry N. Abrams, Inc.

ABRAMS The Art of Books
195 Broadway, New York, NY 10007
abramsbooks.com